CANCELED FLIGHT

101 Tried and True Pigeon Killin' Methods

A.V. JONES

THROCKMORTON PRESS

New York, NY

Publisher

THROCKMORTON PRESS

200 E. 10th Street, #338

New York, NY 10003

t: 646 214 1096

f: 435-514-3712

throckmortonpress.com

Design

Kevin Roberson

kevinroberson.com

ISBN 0-9761416-0-4

No pigeons were killed or harmed
in the printing of this book.

10 9 8 7 6 5 4 3 2 1

Cover:
Michael Sieben
The Surprise Party

Printed in China

DEDICA(U)TION

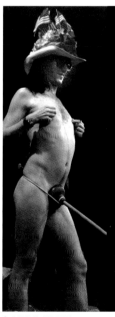

For Philip Bury, lead singer, Buck Naked & the Bare Bottom Boys.

In 1992, while taking his dog for a late-night walk through San Francisco's Golden Gate Park, Buck came upon a cab driver known as "The Pigeon Man." Buck let his dog run off the leash, which scared away some pigeons The Pigeon Man was feeding. After a small altercation, the man pulled out a gun and killed Buck.

If, like The Pigeon Man, you feel a pathological connection to feathered rats, this book is definitely not for you. It works on a humor level you just won't comprehend. Please put it down now... unless you insist on burning it, in which case I thank you for your purchase.

Kill Pigeons, Not People!

© GARY X. INDIANA

CONTENTS

It is estimated around 5 billion passenger pigeons filled the sky when Europeans first arrived in North America. During their migration periods, skies would darken for hours at a time as flocks several thousand feet wide would pass overhead. According to Clive Ponting in *A Green History of the World* (Penguin), "The flocks were so thickly packed that a single shot could bring down thirty or forty birds, and many were killed simply by hitting them with pieces of wood as they flew over hilltops." Man eventually prevailed and the last passenger pigeon died in captivity in 1914.

FIVE BILLION KILLS...now that's what I call taking care of business!!!! Imagine the dedication required by our fellow countrymen to carry out such a commendable task. They stood their ground. They fought long and hard. They won the battles *and* the war.

Ladies and gentlemen, in case you missed it, common street pigeons are invading our skies, ledges, parks, sidewalks, fountains and homes in numbers on par with the passenger pigeon! Once again we find ourselves forced to take a defensive position. We must end the spreading of disease. We must protect our monuments, statues, landmarks and homes. We must stop the pigeons before they take over and our future generations are forced to speak Coo.

Unfortunately, times have changed since the days of the passenger pigeon. No longer can we bear and fire arms at will. Between background checks, costly permits, unsympathetic law enforcement and uppity neighbors, a good old Smith & Wesson just isn't the tool it used to be. No problem. We simply have to be smarter. More cunning. More creative. And more resourceful than our foe.

Well, your good buddy A.V. has compiled 101 pigeon killin' methods to help make this war short and sweet. For each, I've detailed what materials you'll need and how to go about implementing it. My wife suggested using the clever names, which I thought was stupid, but then realized you need a common language when speaking with your fellow soldiers. I've even gone so far as to categorize the methods based on your personality type.

Look, nobody forced me to take the reins. I simply knew no one else would get off their duff and do it. Don't nominate me for President. Don't name your first born after me. Just get out there and get the job done. And remember our ancestors' triumph over the mighty passenger pigeon.

See you on the battlefield,
A.V. Jones

If only Mr. and Mrs. Pigeon hadn't found their way onto good old Noah's Ark. Imagine how different our world would be today. No cooing. No crapping. Wow, I get chills just thinking about it. They say you can't change history, but I say we give it our best shot.

The following methods are for those of you who prefer to live in the past. You know who you are. Always wishing you were alive during so-and-so's reign. On the battlefield. At that historic treaty signing. Whatever. You probably even have a little army of Civil War figurines filling your basement. Well, here's your chance to take a step backward in the name of our future generations.

These methods are borrowed from historical events or situations, both in the past and the not-so-recent past. Don't worry if you aren't too familiar with them... just be sure Mr. and Mrs. Pigeon are taught a lesson.

HISTORY & RELIGION BUFFS

#1
THE OLD TESTAMENT

1 Bible
1 rock sling
several small stones

Learn the story of David and Goliath by reading 1 Samuel 17:41-51 in the Bible. Load a rock sling, swing it overhead in a circular motion and release one end just as a pigeon flies into the stone's path. Keep in mind, after felling the "giant," you too must cut off its head.

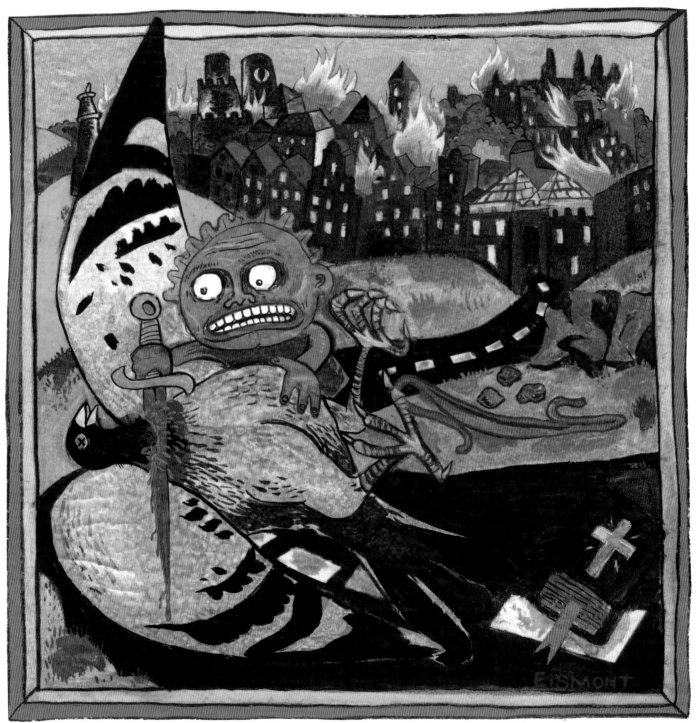

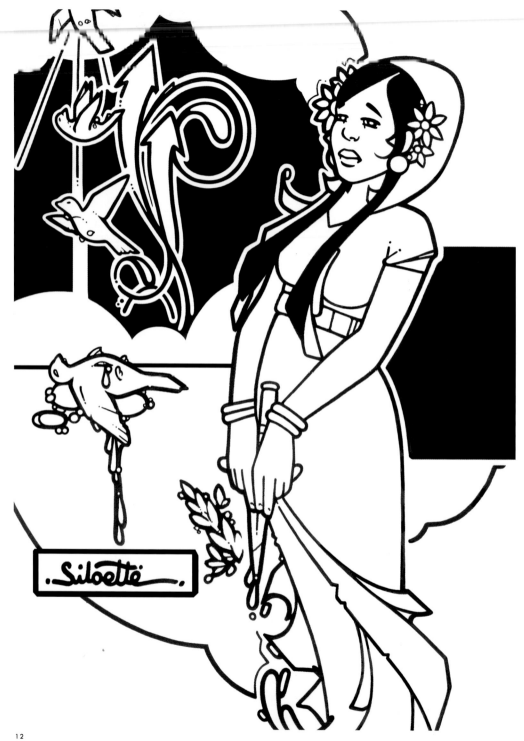

#2
THE OFFERING

1 altar
1 dagger
some rope
a few rose petals

Scatter a few rose petals around the base of an altar with a pigeon strapped to it. Say something profound as you plunge a dagger deep into the bird's chest. As the clouds part, look skyward and thank the gods for accepting your gift.

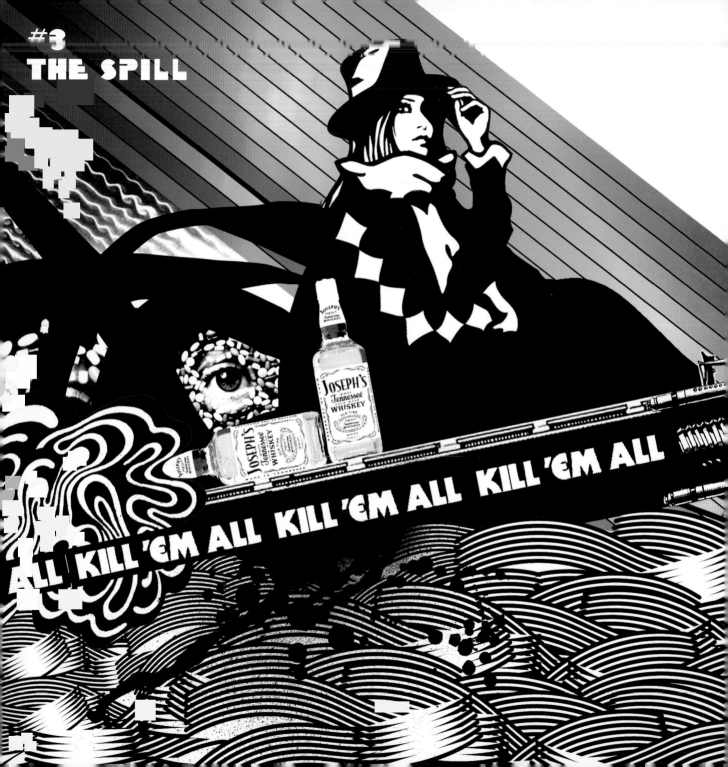

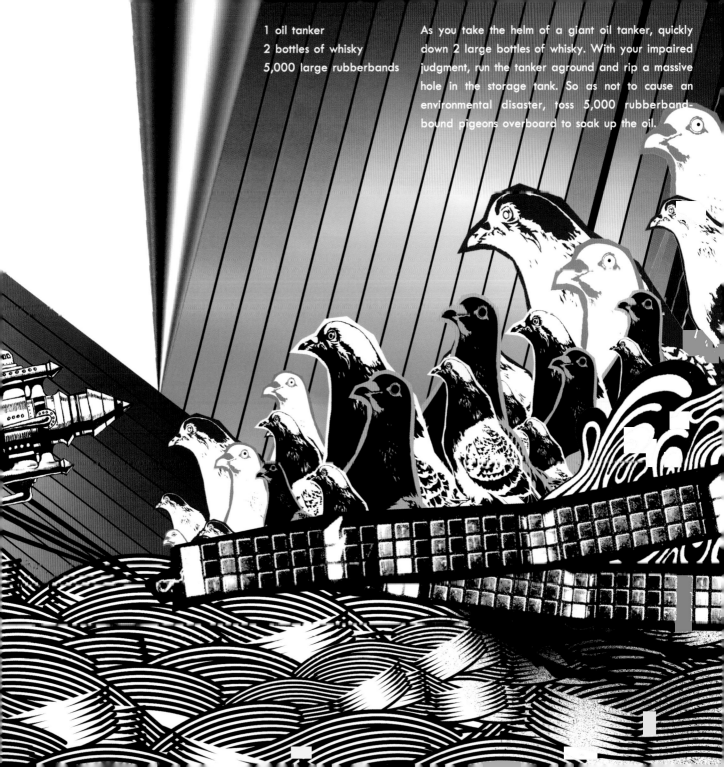

1 oil tanker
2 bottles of whisky
5,000 large rubberbands

As you take the helm of a giant oil tanker, quickly down 2 large bottles of whisky. With your impaired judgment, run the tanker aground and rip a massive hole in the storage tank. So as not to cause an environmental disaster, toss 5,000 rubberband-bound pigeons overboard to soak up the oil.

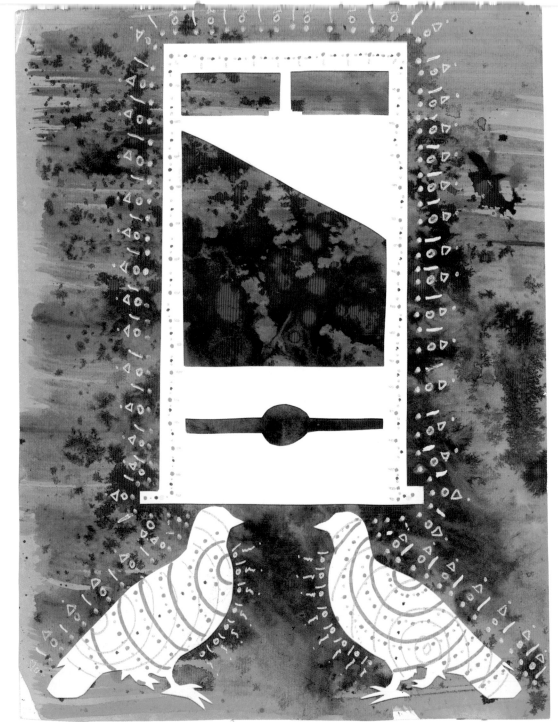

#4
THE FRENCH REVOLUTION

1 18th century guillotine
1 loaf of bread

Spread small pieces of bread on the chopping block of a guillotine. Just as a few pigeons begin enjoying the lunch you've provided, pull the cord. Don't worry if you chop off more than the pigeon's head. The important thing is blade-meets-bird-meets-death.

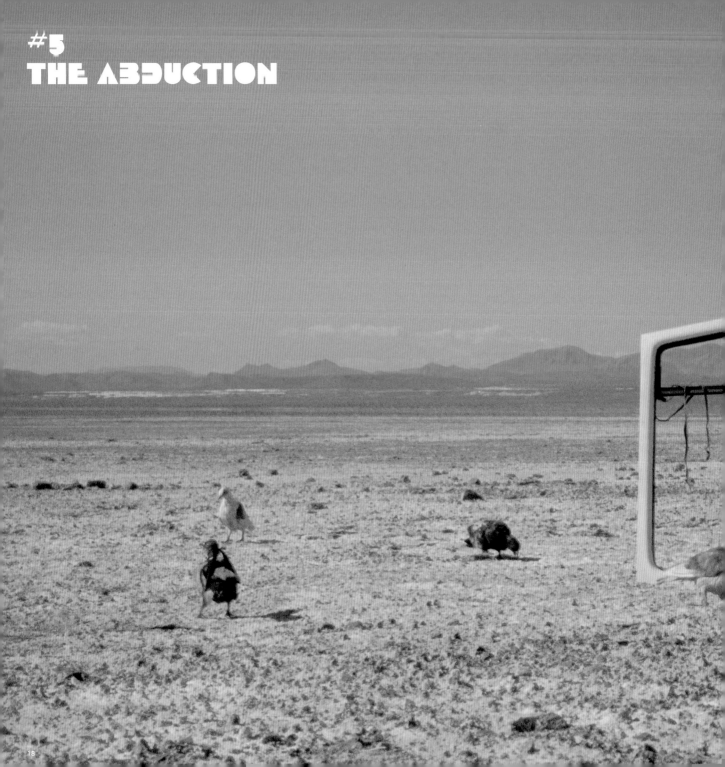

#5
THE ABDUCTION

1 old car door
1 can of paint
1 paintbrush
several loaves of bread

Lure as many pigeons as possible to Area 51, Nevada, with several loaves of bread. On an old car door, paint a message from the pigeons to the aliens offering themselves as test subjects. Set the door next to the pigeons and get out of there before "they" see you.

ALIENS:
Look No Further—We Are This Planet's Most Intelligent Creatures. Take Us Aboard Your Spaceship And Conduct Horrible Tests On Us. It's OK If We Die— We're Sacrificing Ourselves.
—The Pigeons

Is your idea of heaven an uncrowded hardware store? Do you create problems around the house just so you can repair 'em? Well, today is your lucky day.

That's right, Mr. Fix It, your rank has just been elevated to *Artesano Importante*. Forget about restoring that Cherry Red '68 Camaro. And those plans for a mailbox in the shape of your house? Scrap 'em. From this day forward, every swing of the hammer and turn of a screw will be regarded as an act of vital necessity.

The following several methods will give you a reason to use your favorite tools with a newfound passion and purpose. Who knows, they might even give you an excuse to go out and buy new ones. So sharpen those blades, gas up those machines and put on your best pair of overalls — it's time to do a little work around the house!

HANDY-MEN & LESBIANS

#6
THE FLAMBÉ

5 gallons of gasoline
1 match
some bread

At a nearby pigeon-infested square, pour a large amount of gasoline onto the ground (away from small children and pets). Toss a few pieces of bread into the center of the puddle. Just as several pigeons begin fighting for the bread, light a match and throw it into the pool.

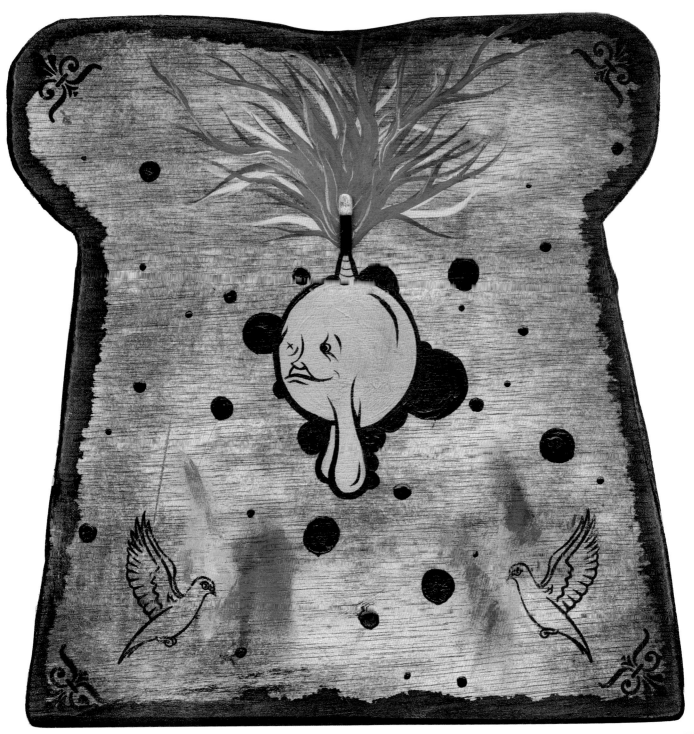

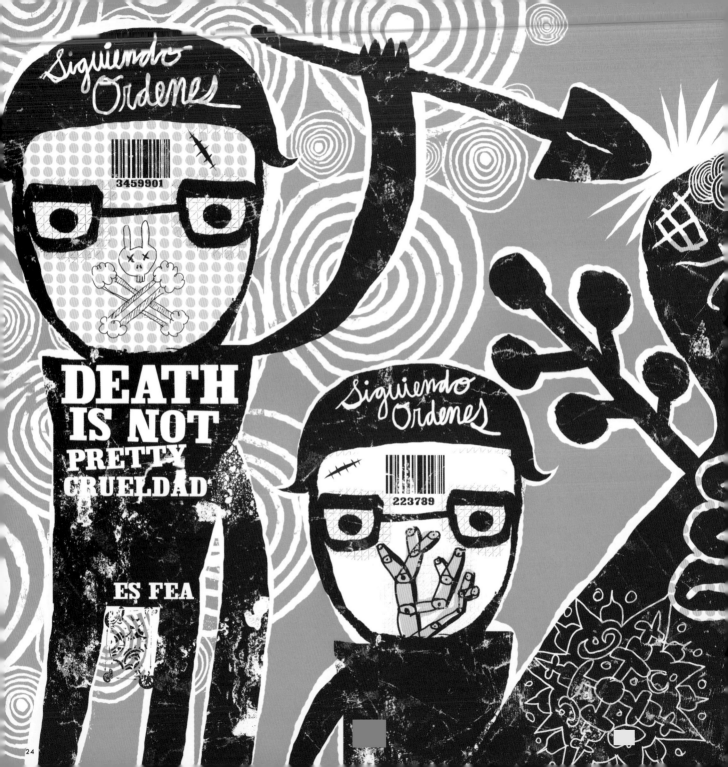

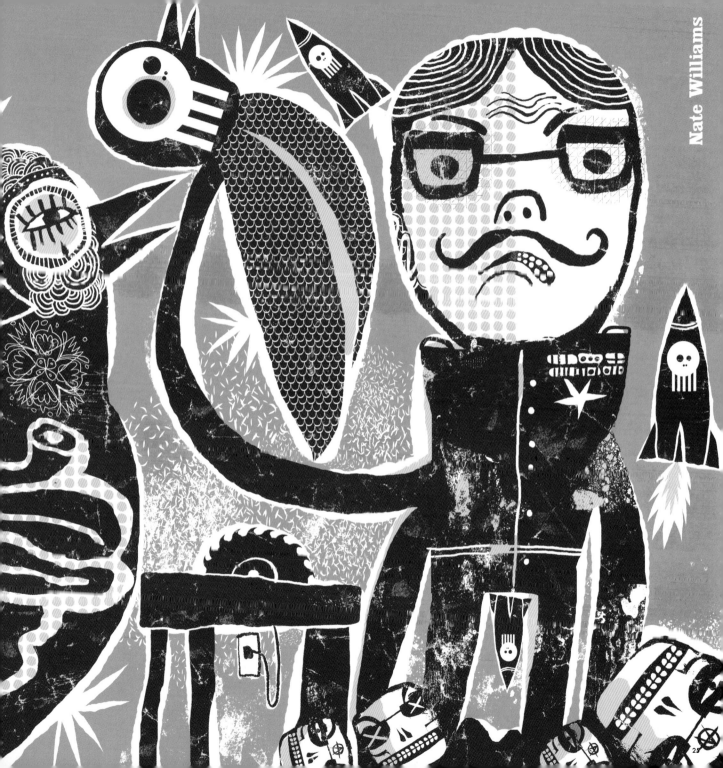

#7
THE CARPENTER ◂

1 large table saw
1 table
some bread

Stick small pieces of bread to the tips of a table saw in your driveway. When a few curious pigeons begin snacking, plug in the saw. If any survive, grab a tool (shovel, nail gun, lawnmower, etc.) and finish the job you've started. Afterward, simply let the neighborhood cats clean up the mess.

#8
THE SPLITTING HEADACHE ▸

1 shovel

Sneak up behind a pigeon and whack it over the head with a shovel — not enough to kill it, just enough to put it on death's doorstep. Call 911 and begin a long-winded, unintelligible fit of hysteria. After 10 minutes or so hang up. This should give the bird plenty of time to die a slow, painful death.

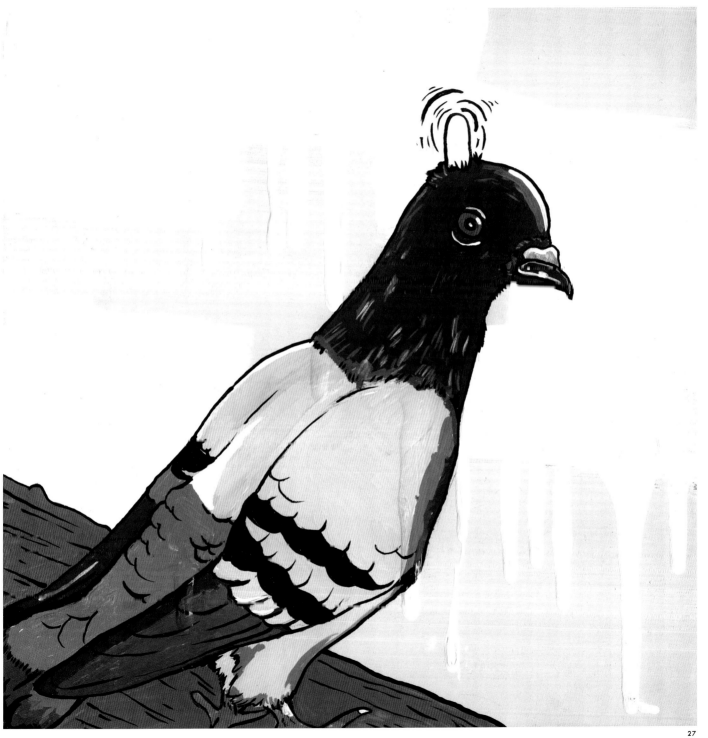

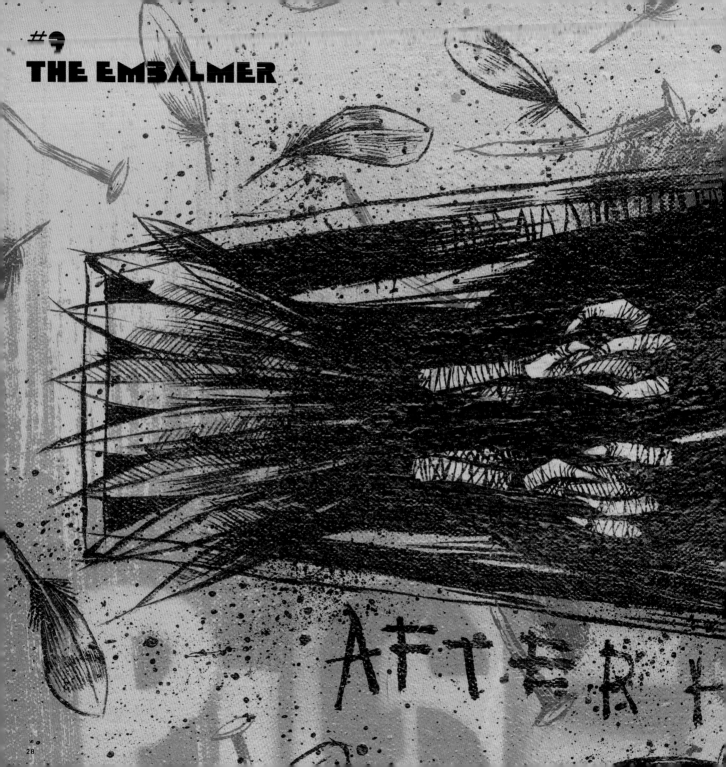

#9
THE EMBALMER

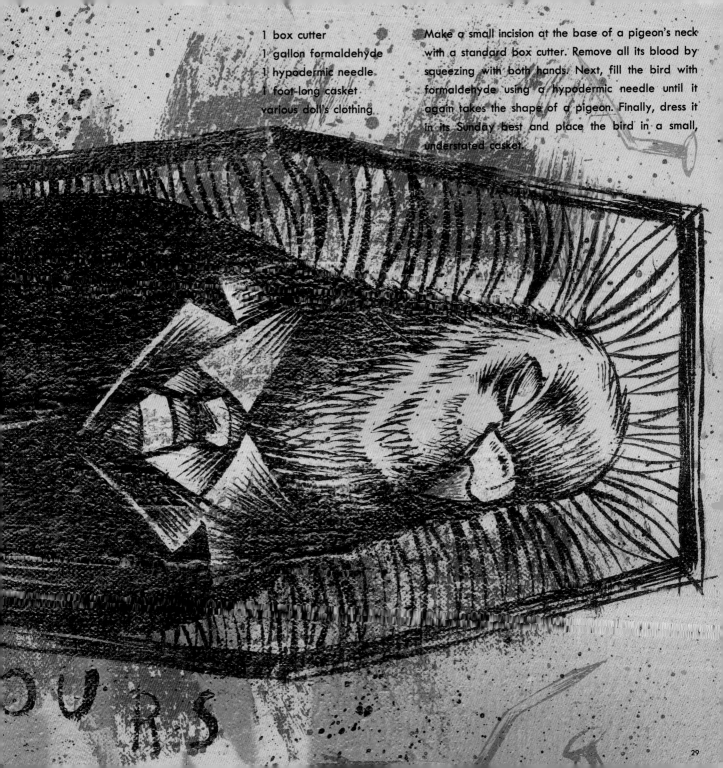

1 box cutter
1 gallon formaldehyde
1 hypodermic needle
1 foot-long casket
various doll's clothing

Make a small incision at the base of a pigeon's neck with a standard box cutter. Remove all its blood by squeezing with both hands. Next, fill the bird with formaldehyde using a hypodermic needle until it again takes the shape of a pigeon. Finally, dress it in its Sunday best and place the bird in a small, understated casket.

several "spine-breaker
rat traps
1 loaf of bread

Head down to a nearby park early in the morning and carefully set several "spine breaker" rat traps. Place bits of bread on and around the traps. Grab a cappuccino at a nearby café and enjoy the show.

#10
THE BETTER "MOUSE" TRAP

1 bottle ethyl ether
 $(C^2H^5)^2O$
1 snowblower
1 loaf of bread

Open a bottle of ethyl ether (don't breathe in!) and set it next to some scattered bread in a pigeon-infested square. As the birds enjoy their lunch you'll notice them becoming very sleepy. Next, fire up a snowblower and take care of business. Aim the exit chute away from any people applauding your performance (everyone else is fair game).

#11
THE BLIZZARD OF '85

#12
THE OLDEST TRICK IN THE BOOK

1 lawnmower (motorized)
1 stick
some bread
some string

(a) Start a lawnmower. (b) Brace one end in the air with a stick. (c) Scatter some bread on the ground under the mower. (d) Tie one end of some string to the bottom of the stick and hold onto the other end 20-30 feet away. (e) As soon as a few pigeons begin enjoying the bread, give the string a good heave-ho. (f) Mission accomplished.

a

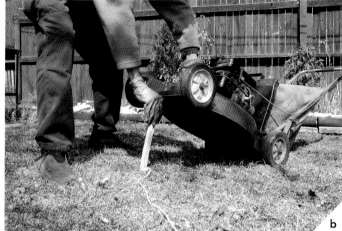

b

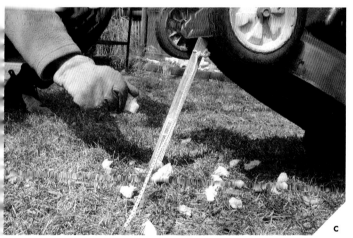

c

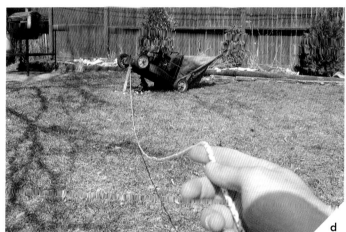

d

e

f

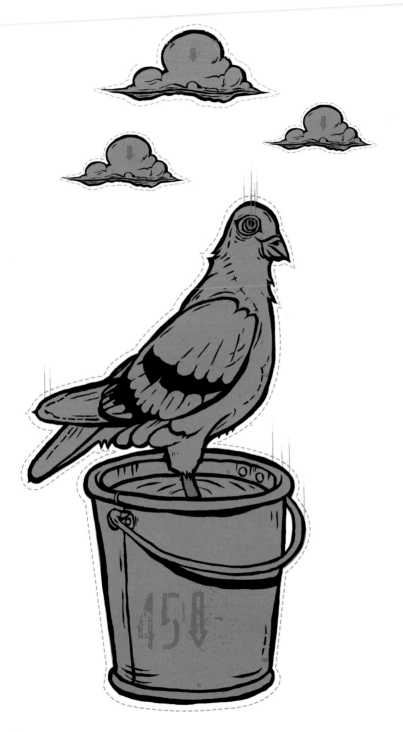

#13
THE MOBSTER

1 bag quick-set concrete
1 metal bucket
1 bridge

Mix some quick-set concrete in a metal bucket. Once it begins to harden, place a pigeon's feet into the mixture and hold until they're firmly set. Next, head to a nearby bridge and throw bucket, concrete and bird into the water below.

#14
THE ABRACADABRA

1 magic book
1 small wooden box
1 sharp saw
1 audience

Read in a magic book how to saw a woman in half. Now, forget everything you just read. Catch a pigeon and place it in an appropriate wooden box. Begin sawing. Open the box and show your audience that you did indeed saw the pigeon in half.

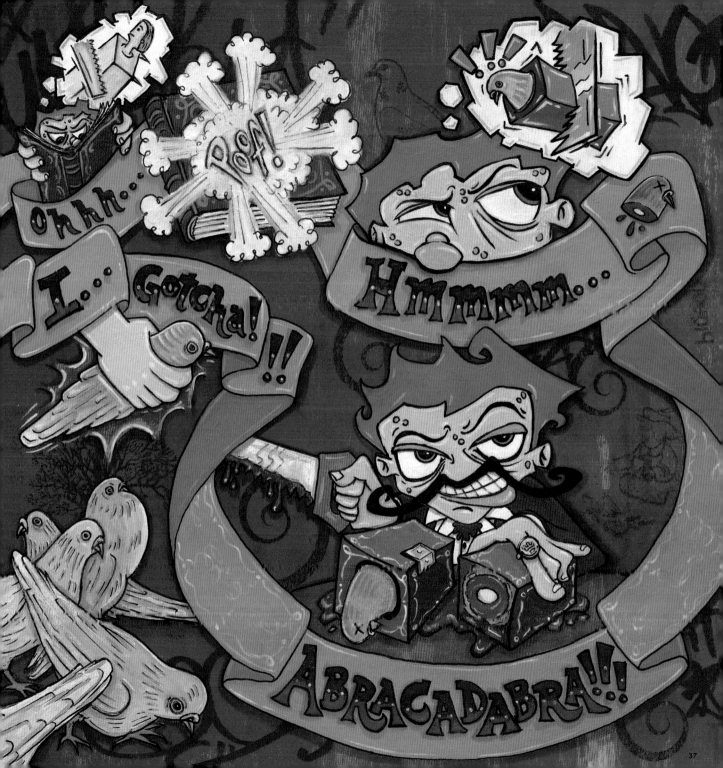

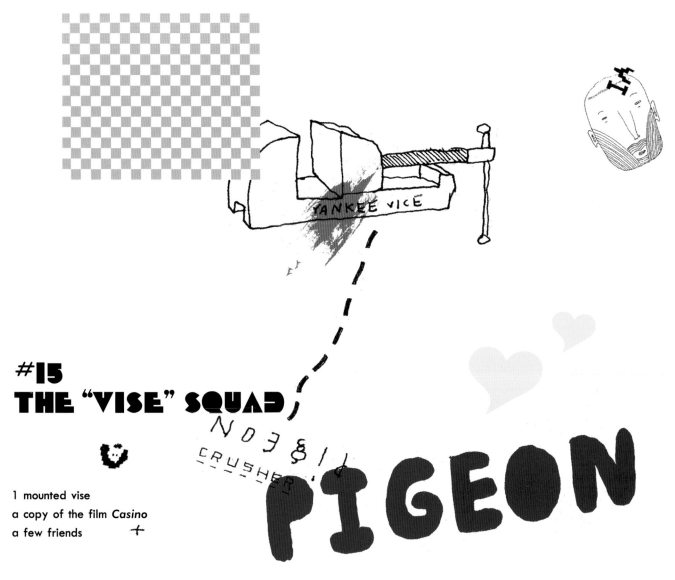

#15
THE "VISE" SQUAD

1 mounted vise
a copy of the film *Casino*
a few friends

Gather a few friends and assign each a role from the film *Casino*. After rehearsing the head-in-the-vise scene, yell, "Action!" (If you haven't figured it out, use a pigeon in place of the cheatin' bastard who gets his head crushed in the vise.) If you're feeling extra ambitious, rent a camera and sell your version on the black market.

HEADCRUSHER

HEADCRUSHER

HEAD CRUSHER

PIGEON

PIGEON BIRD

BAD MEN

badmen killing pigeons

#16
THE EXTRA CRISPY

1 propane BBQ grill
1 bottle lighter fluid
1 long broomstick

Once the closed-minded guests have left your BBQ party, throw a pigeon onto the unlit grill and cover it with lighter fluid (the whole bottle). Next, close the lid and use a broomstick to hit the ignite button. Ka-boom!

Class clowns, this one's for you! You've always known how to get a laugh, and for once it won't be in vain. Think of it as comedy with a purpose. Sorta like Robin Williams in *Good Morning, Vietnam*. That guy really made war fun, huh? Well, so can you!

On the next few pages you'll find several methods guaranteed to help you get the last laugh. And unlike traditional comedy, these get funnier each and every damn time you use 'em. You'll have friends, family, coworkers and the mailman peeing their pants so often, you might have to start handing out adult diapers.

So without further ado, take a gander at your latest bag of tricks.

MERRY PRANK-STERS

#17
THE HIBACHI

1 well-planned diversion

At a Teppanyaki restaurant, watch in amazement as the chef prepares your food on the tableside grill. Using a well-planned diversion, direct his attention away from the table and quickly slip a pigeon under his fast-moving blades. At this point you should leave since it's not wise to eat anywhere that serves pigeon.

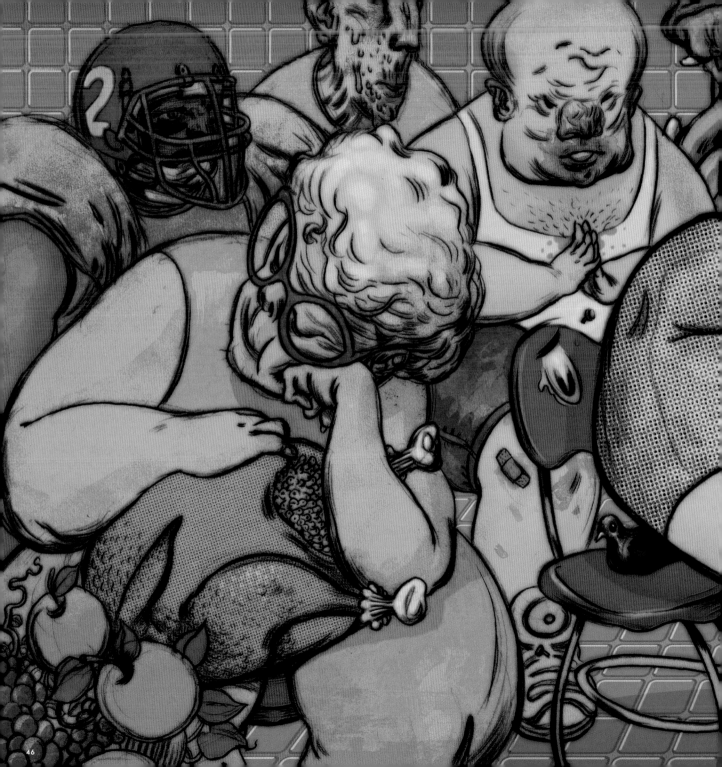

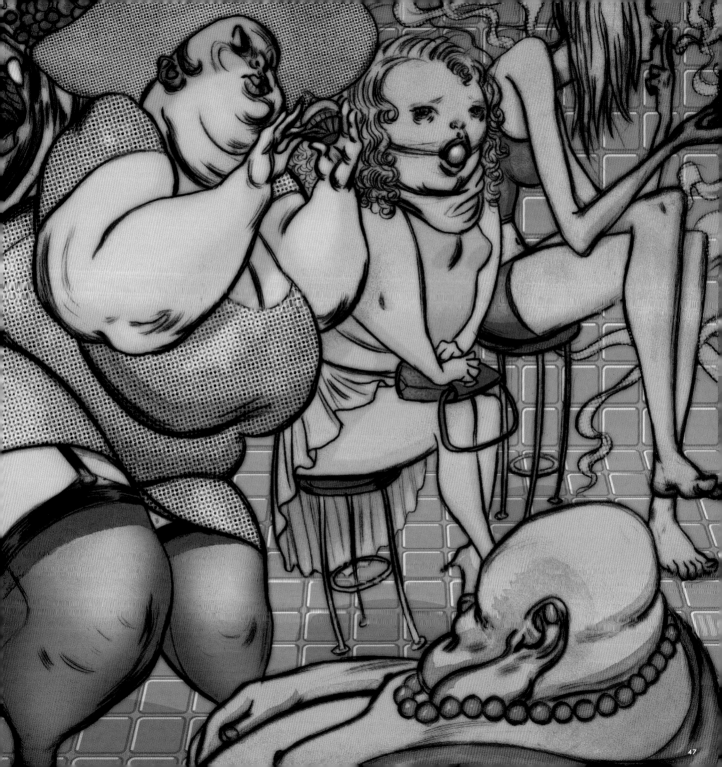

#18
THE BIG MAMA

1 big fat lady
1 moist snack cake

Attend an Overeaters Anonymous meeting and place a snack cake in one corner of the room. Lean over to the most grossly-overweight woman and whisper, "Hey, is that a moist snack cake?" In no time flat she'll make a beeline for her little piece of heaven. Before she sits down place a pigeon on her chair. She won't feel a thing.

1 scalpel
1 needle
some anesthesia
some magnets
some thread

Surgically implant magnets into the backs of several anesthetized pigeons. When they wake up, explain how the next train coming through town is carrying a poisonous birdseed mixture meant to wipe out their species. They'll then protest by lying down on the train tracks. Once they realize the train ain't stoppin' and they ain't gettin' up, tell 'em what's really on the train: loaves of bread.

#19
THE MIDNIGHT EXPRESS

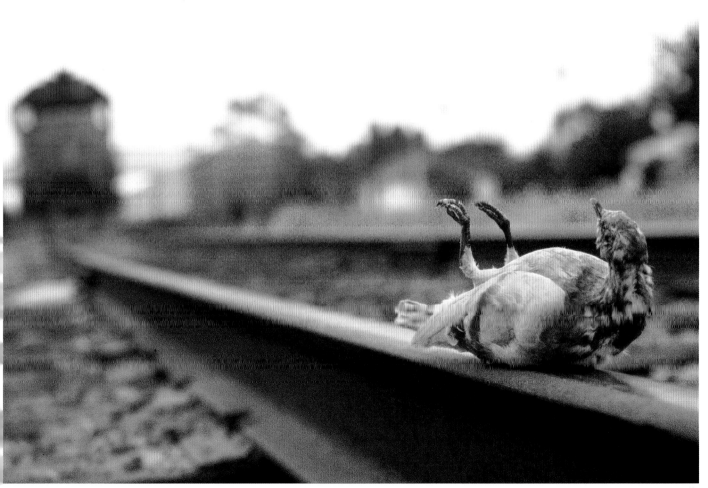

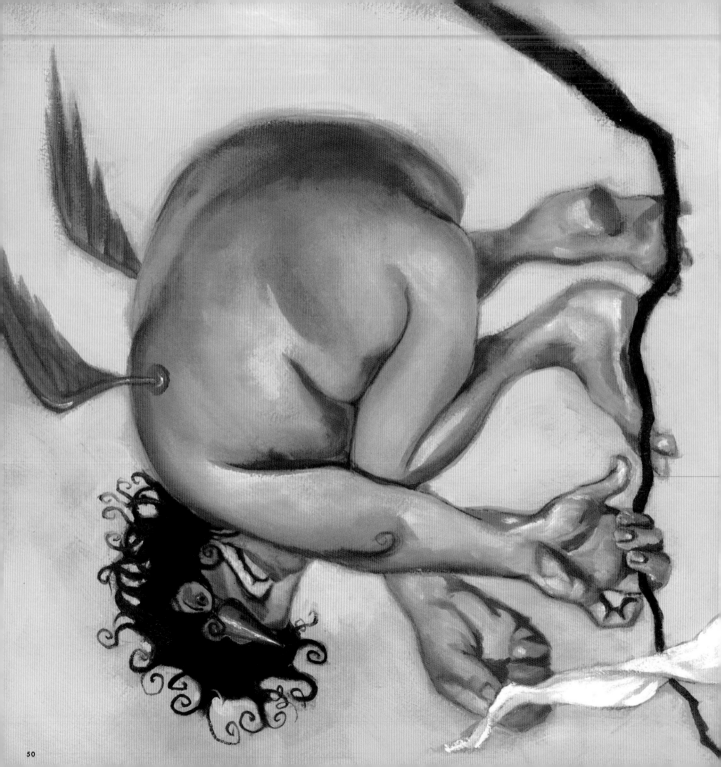

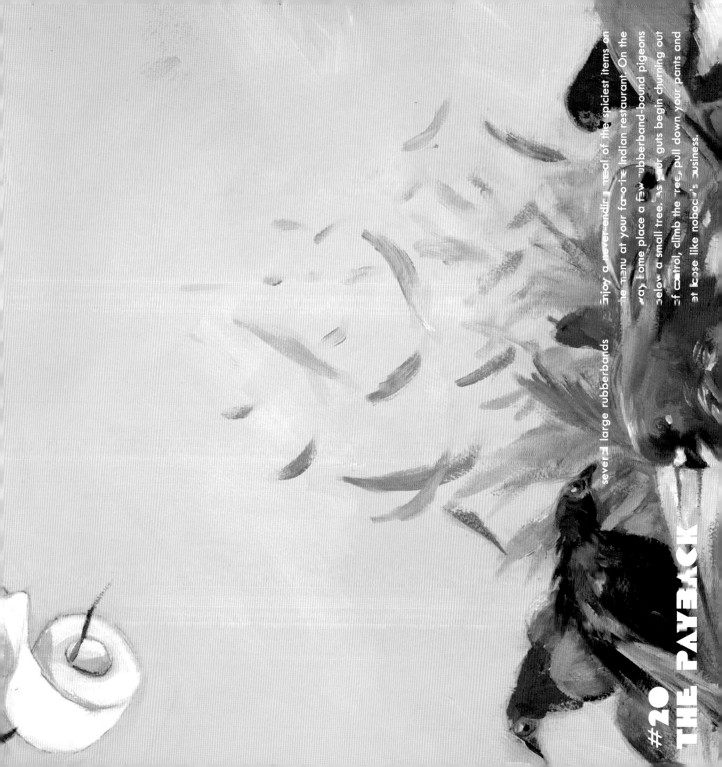

several large rubberbands

Enjoy a never-ending meal of the spiciest items on the menu at your favorite Indian restaurant. On the way home place a few rubberband-bound pigeons below a small tree. As your guts begin churning out of control, climb the tree, pull down your pants and let loose like nobody's business.

#20 THE PAYBACK

5-7 recipe cards
1 magic marker
several large rubberbands
some string

On several recipe cards write phrases such as, "Step aside Bloods and Crips, da pigeons is takin' over." Using the string, tie one card around each rubberband-bound pigeon's neck. Next, drop the birds off in the most gang-infested section of town and hightail it out of there before someone sees you associating with da pigeons.

#21
DA 'HOOD

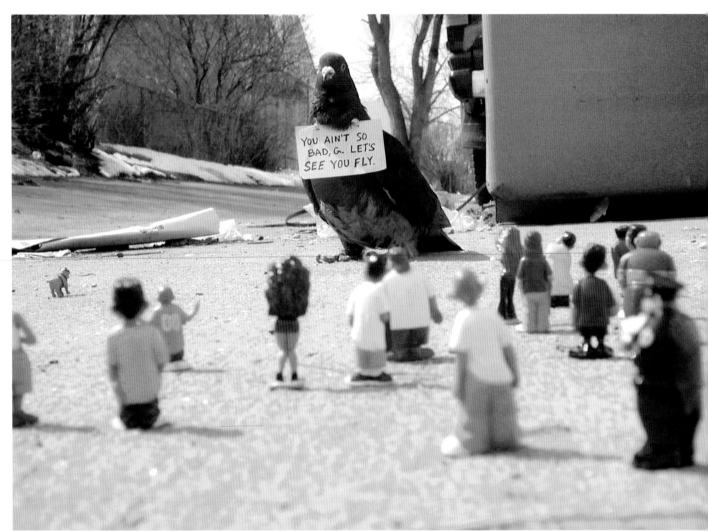

some duct tape

On the back roads of a small Montana town, tape one pigeon to the middle of each road sign. Later that night, the drunker-than-a-skunk locals will leave the bars to embark on their traditional evening ritual — shooting road signs. Their confusion will quickly be replaced by sheer joy as they chalk up kill after bloody kill.

#22
THE SITTING "DUCK"

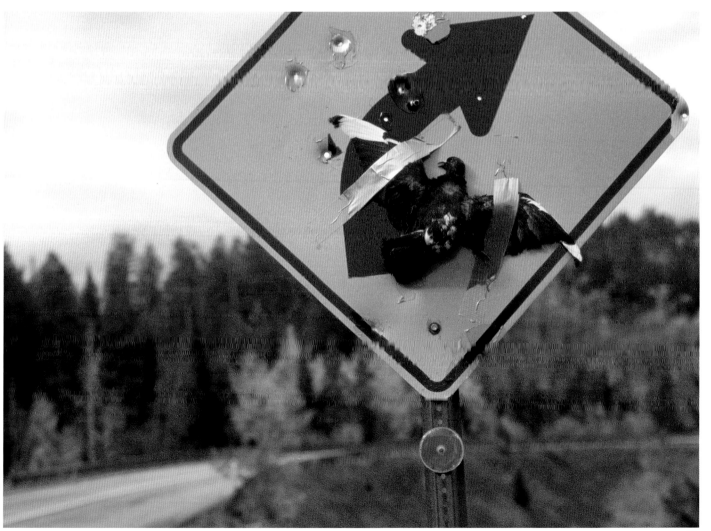

If they'd let me vote for the Nobel Prize in Chemistry, I'd stuff the ballot box with your name. Sure, I enjoyed beating up people like you in high school, but these days I have nothing but respect. I mean with all those chemicals and that deadly science stuff at your disposal you could practically take out an entire city's flock with some crazy concoction.

Anyway, on the following pages you'll find some "experiments" I think you'll love. Most don't require a laboratory and with a nearly endless supply of test subjects you can perform trials over and over and over again. After all, it's not good science unless you're absolutely, positively sure your hypothesis is proven beyond a doubt.

"And the Nobel Prize for Pigeon Killing goes to ."

MAD SCIEN- TISTS

#23
THE AIR SHOW DISASTER

12-14 oz. strychnine
1 umbrella

Brightly-colored and delicious looking, strychnine simply needs to be scattered where several hungry pigeons have gathered. You'll notice most birds lose all motor function around 40-50 feet above the ground. (Don't forget an umbrella!)

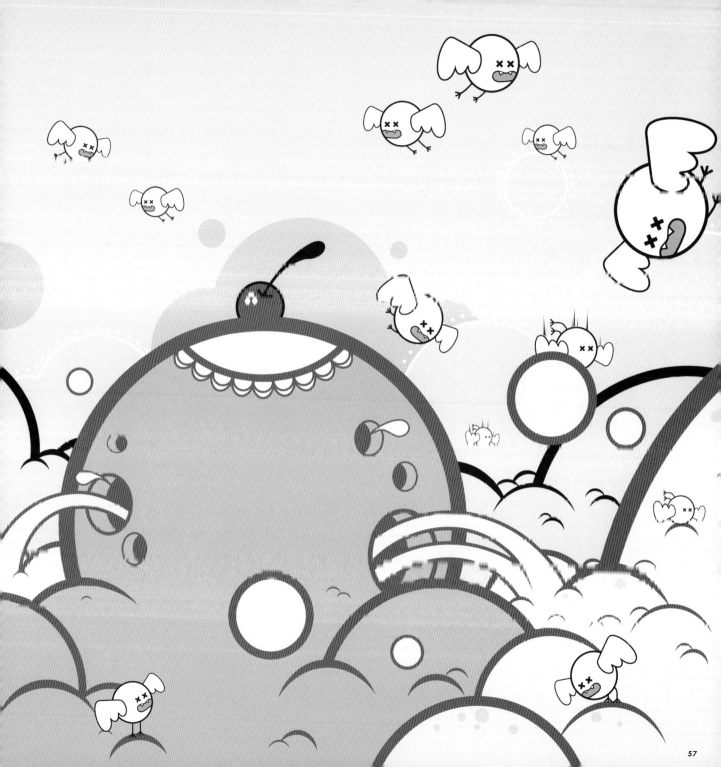

1 lb. raw hamburger meat
1 box rat poison

Fold rat poison into raw hamburger meat. Roll the mixture into balls approximately 1 inch in diameter. Drive to a nearby pigeon-infested park and toss the balls in close proximity to the birds. As you drive away laughing maniacally, adjust your rearview mirror so you can enjoy the show.

#24
THE MAD COW

#25
THE JUNKIE

▶

1 bottle dish detergent
1 hypodermic needle
1 pair of earplugs

Using a hypodermic needle, inject dish detergent into a pigeon's veins. Since the squealing will be almost too much to bear, use a pair of earplugs to shove in the bird's mouth.

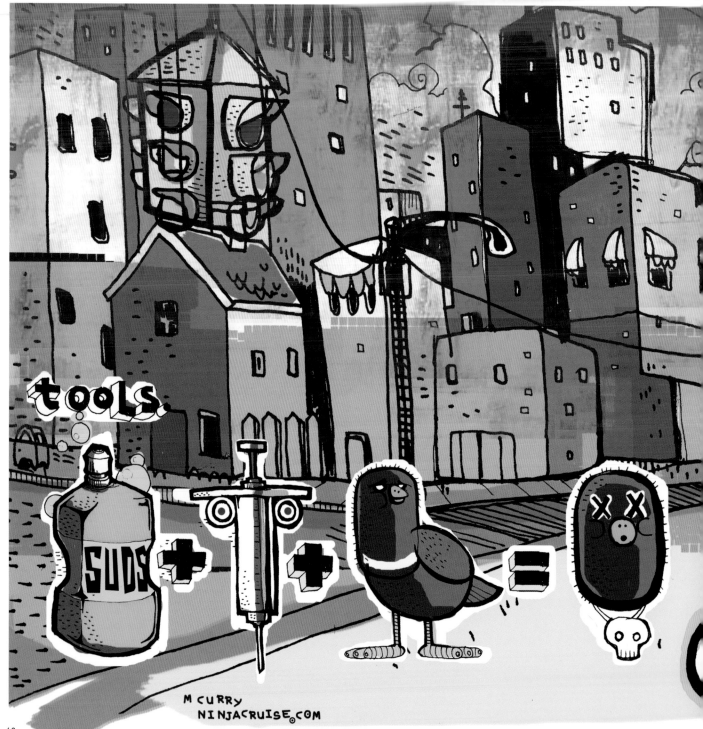

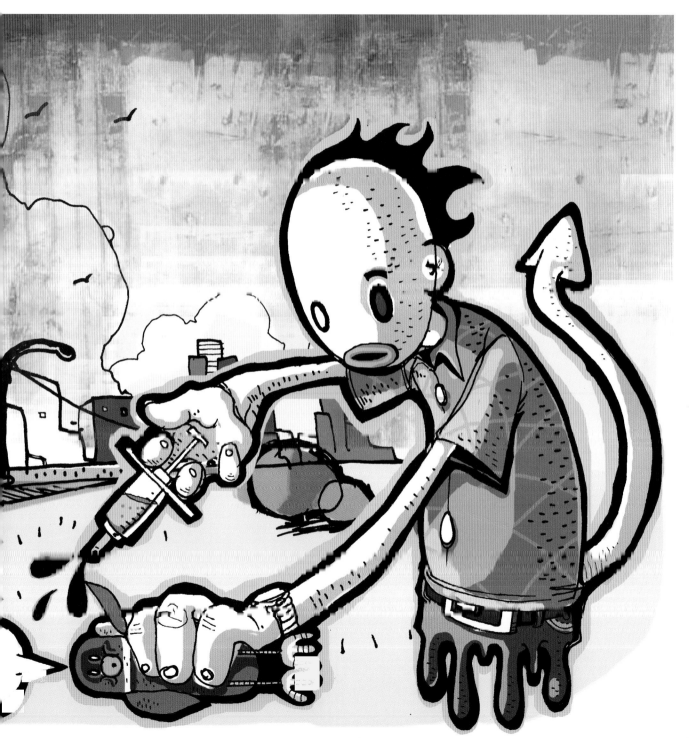

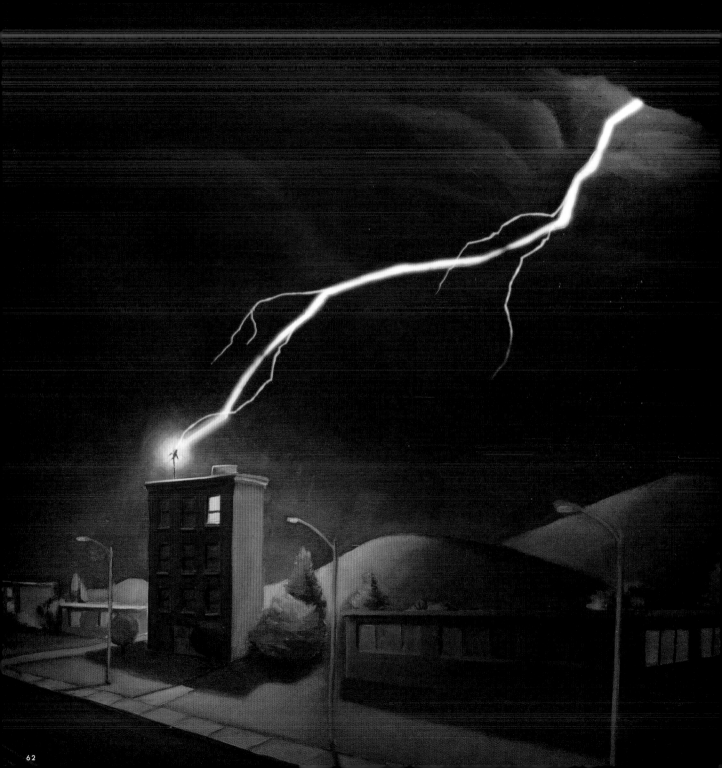

#26
THE BEN FRANKLIN

1 lightning rod
1 roll duct tape

Find the roof entrance of a tall building and secure a pigeon to the lightning rod using duct tape. WARNING: DO NOT STICK AROUND TO SEE WHAT HAPPENS. Don't worry, if several days pass without an electrical storm the effects of starvation will accomplish your desired result.

THE HOUDINI

materials

- 200 gallons of water
- 14 combination locks
- 1 large glass tank
- 1 set of heavy chain
- 1 stopwatch

Wrap heavy chain
inch of a pigeon.
locks to secure
several places, t
tank of water.
to see how long t
bird to escape
or so yn can pre
its a dvd. Get
repeat until suc

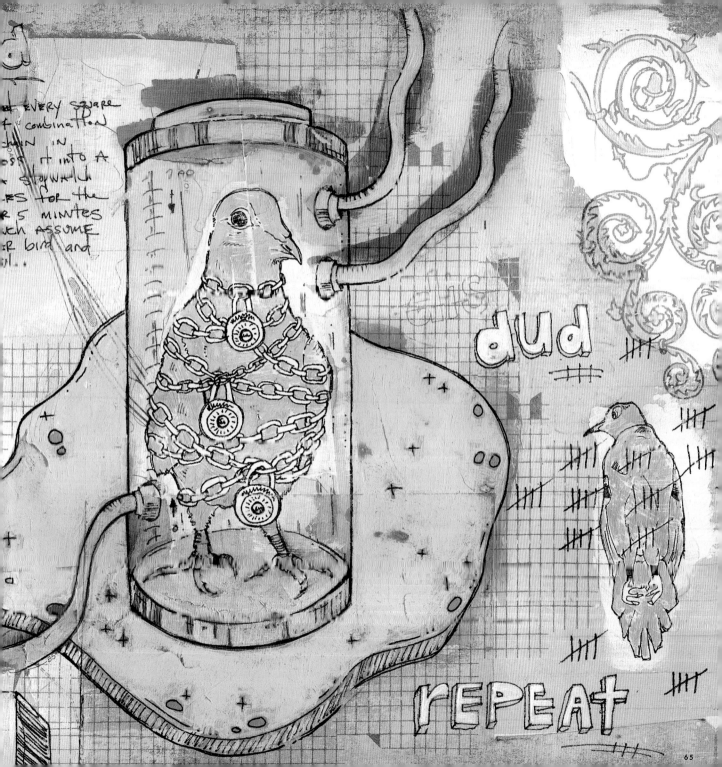

#28
THE TWEAKER

65 gallons sodium hydroxide
50 gallons diluted hydrochloric acid
16 gallons ethyl ether
10 small glass bottles
2 large eyedroppers
several Bunsen burners

Set up a meth lab in the basement of an abandoned building. During production, go to lunch and "accidentally" let 50 pigeons loose in the lab. Next, head straight home and watch the live TV news report about *another* meth lab explosion.

#29
THE STRATOSPHERE

1 weather balloon
some helium
some string

Tie one end of some string to a pigeon and the other to a helium-filled weather balloon. Point the balloon in the direction of the sun and let 'er fly. Chances are the bird and balloon won't make it to the sun, but don't let that ruin your day — the bird ain't coming back. End of story.

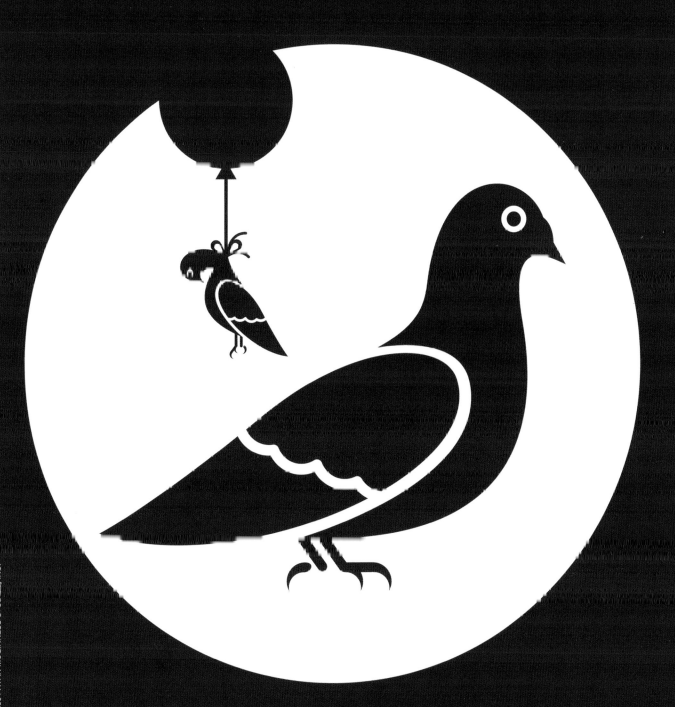

I'm acutely aware the animal rights people will be up in arms over our cause. It's obvious they'll be so focused on the killing-of-animals part, they'll completely miss the bigger picture. Ask them if it's okay to kill a rat or a mouse and they'll hem and haw 'til the cows come home. I digress. The point of this is to introduce the next chapter.

Animal lovers...I respect you people the most. I mean, after all, you love animals and yet you're willing to whack a few birds for the good of mankind. On the following several pages you'll find a whole slew of God's creatures doing your dirty deeds for you. You'll be aiding the cause while your hands and conscience remain virtually clean.

Bless you people.

ANIMAL
LOVERS

#30
THE MAN'S
BEST FRIEND

1 large pit bull
1 package of dog treats
1 large rubberband
some string

Tie a dog treat to one end of a 3-foot piece of string and the other end around the neck of a rubberband-bound pigeon. Starve a pit bull for several days then let him go in your backyard. Ignoring the treat completely, he'll go straight for the bird. Good dog.

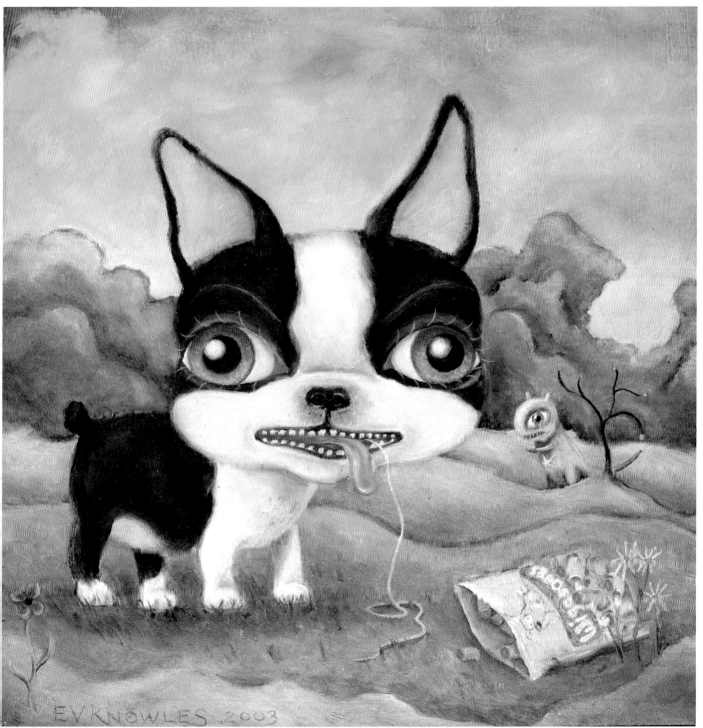

#31
THE CLACKER

1 ball of string

Create a noose at each end of a 4-foot piece of string. Slip opposite ends of the string around the necks of two pigeons. Release the birds. Sit back and enjoy the show as the birds live out their unfortunate (some may say entertaining) fate.

#32
THE STING

1 large beehive
1 beekeeper's outfit
some rope

Wearing a beekeeper's outfit, tie one end of a 3-foot piece of rope to a pigeon's feet and the other end to a beehive. As the bird tries to escape it'll work the bees into a frenzy. Only one thing will follow – a whole lot of stingin' and dyin'.

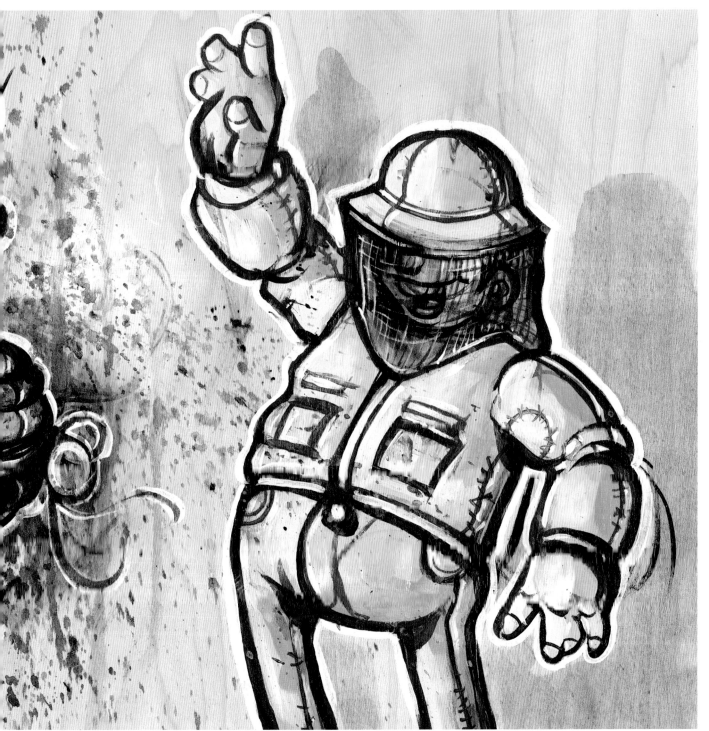

1 can red spray paint
a few zipties

Sneak onto a cattle ranch and get as close as possible to the biggest, meanest looking bull. Next, take aim and throw a red, spray-painted, ziptie-bound pigeon in close proximity to the burly beast. Olé!

#33
THE EL TORO

1 large, bloody steak
1 roll of duct tape

Visit your local zoo and head straight for the lions. Duct tape a pigeon to a large, bloody steak and toss the "meal" where several cats can fight over it. Nice kitty.

#3.
TH SERENGETI

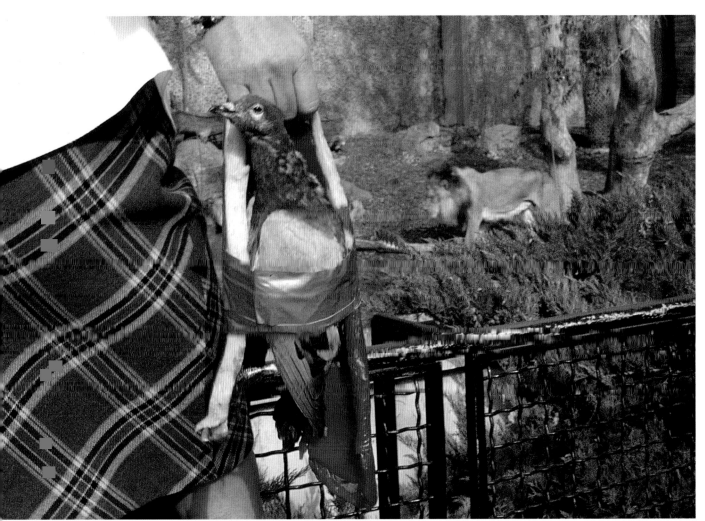

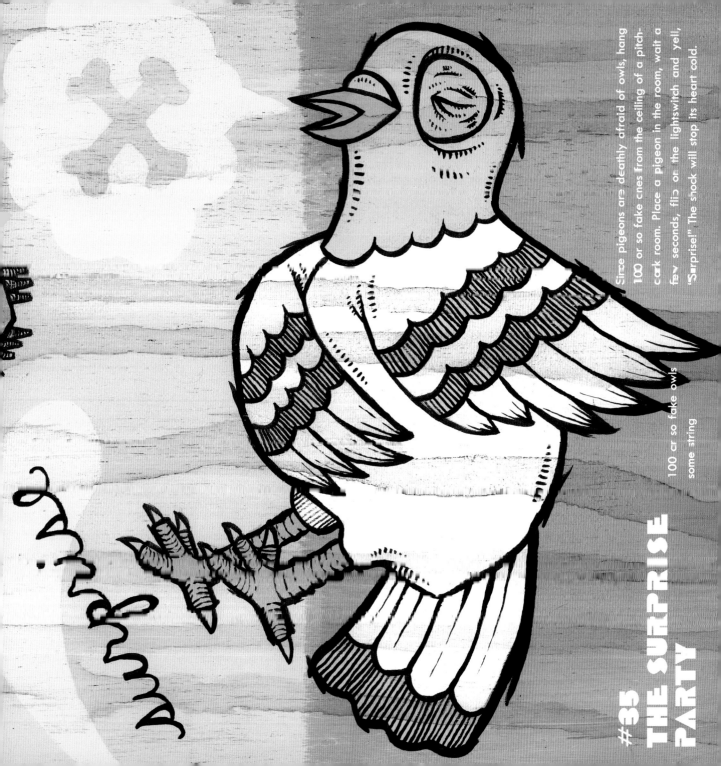

Since pigeons are deathly afraid of owls, hang 100 or so fake ones from the ceiling of a pitch-dark room. Place a pigeon in the room, wait a few seconds, flip on the lightswitch and yell, "Surprise!" The shock will stop its heart cold.

100 or so fake owls

some string

#35
THE SURPRISE PARTY

#36
THE FEEDING FRENZY

200 hungry piranhas
1 fishtank
1 large rubberband

Drop a rubberband-bound pigeon into a fishtank filled with 200 hungry piranhas. It won't be long before there's nothing left and the piranhas are looking at you impatiently. Well c'mon, give 'em another. After devouring three or four more they'll be ready for dessert...that's right — another pigeon.

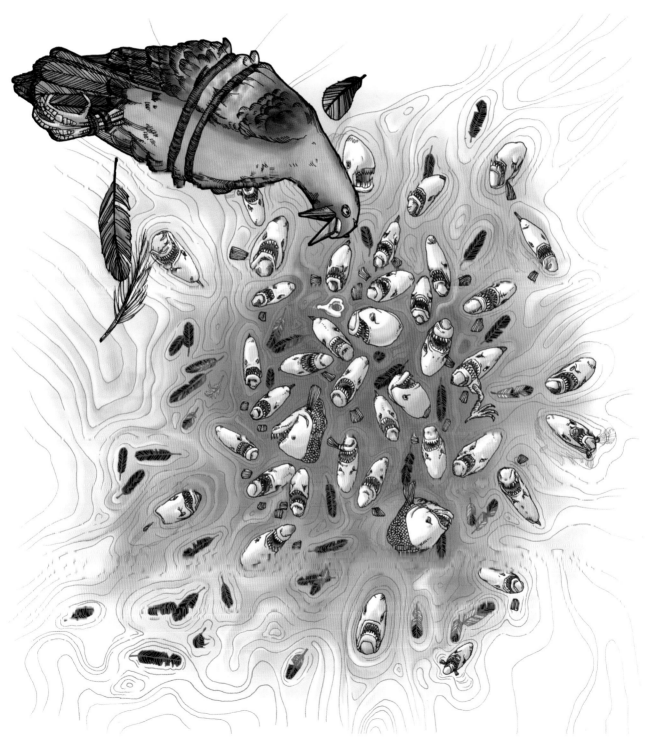

You people scare me...in a good way, of course. Maybe you suffered a major head trauma. Maybe you were mistreated as a child. I don't know, and personally I don't really care. Look, I won't sit here and judge you based on your sick and twisted mind. I'll simply thank you and stay out of your way.

Being the gentle-hearted person I am, I needed a little help coming up with the following methods. Most came from the warped brain of my 8-year-old nephew, Ferris. Hopefully there are a few here you haven't already thought of. Also, I made sure to include a wide assortment because I know you people will be extra busy and I wouldn't want you getting bored.

In a war as demanding as this, nothing beats a good mercenary. Carry on, soldier.

BLOOD-
THIRSTY
UNSTABLE
TYPES

#37
THE BUTCHER

1 very sharp cleaver

Capture as many pigeons as possible (tranquilize, sweet talk, trick, etc.). Then, simply use a cleaver to chop, chop, chop 'til you can't chop no more. When finished, pat yourself on the back and consider it a job well done.

#88
THE BLOW JOB

1 high-powered wind tunnel

1 hammer

Enter a wind tunnel facility and secure a pigeon to the testing block. Using a hammer, smash the bird to a bloody pulp. Next, turn on the machine and let the wind blow all the blood, guts and feathers where you won't have to deal with 'em.

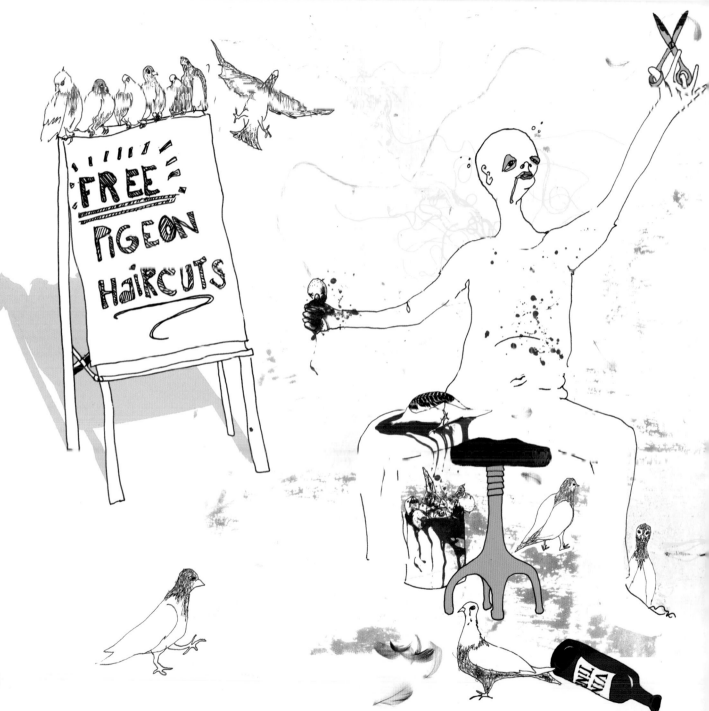

#39
THE SALON

1 pair of sharp scissors
1 chair
1 posterboard
1 marker

Place a chair in a pigeon-infested square with a sign
next to it reading: Free Pigeon Haircuts. As your first
"customer" sits down, get carried away with a story
you're telling and "accidentally" cut the bird's head
off. Remove the evidence and get ready for your
next appointment.

#40
THE O-K CORRAL

1 hot branding iron

Rustle up several pigeons however you see fit. Using a scorching-hot branding iron, apply adequate pressure to the body of each bird. So there won't be any question as to who owns it, continue pressing until the brand passes completely through to the other side.

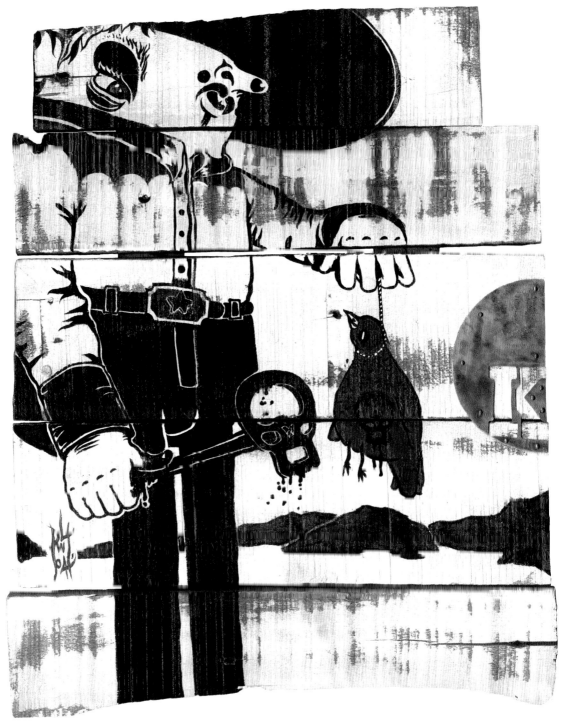

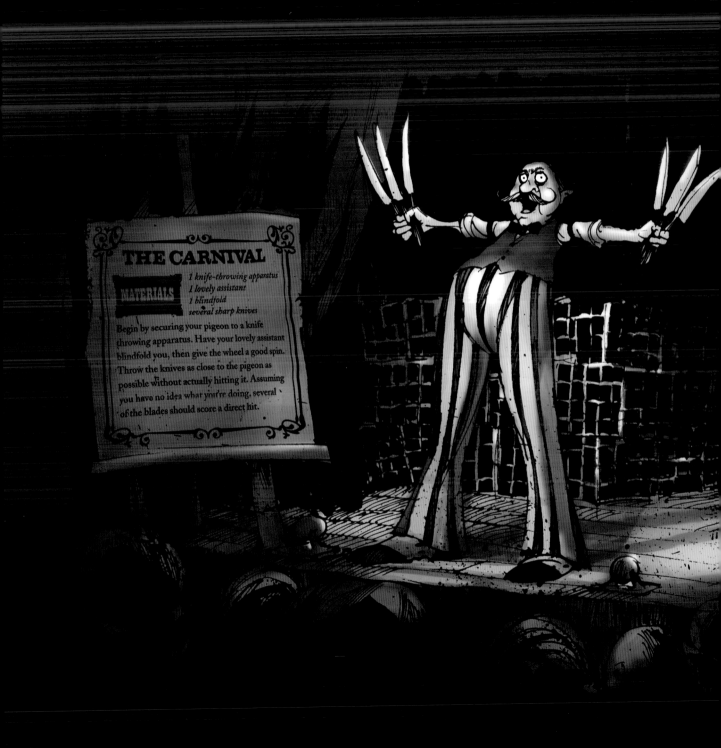

THE CARNIVAL

MATERIALS

1 knife-throwing apparatus
1 lovely assistant
1 blindfold
several sharp knives

Begin by securing your pigeon to a knife throwing apparatus. Have your lovely assistant blindfold you, then give the wheel a good spin. Throw the knives as close to the pigeon as possible without actually hitting it. Assuming you have no idea what you're doing, several of the blades should score a direct hit.

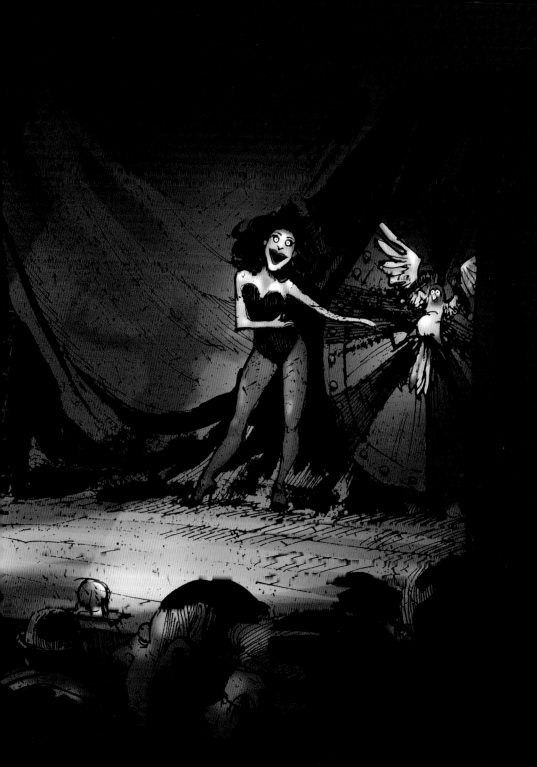

a good heave-ho

While waiting on the platform for your subway train, quietly stand right behind an unsuspecting pigeon. As the train pulls into the station, give the bird a good heave-ho onto the tracks.

#42
THE COMMUTER

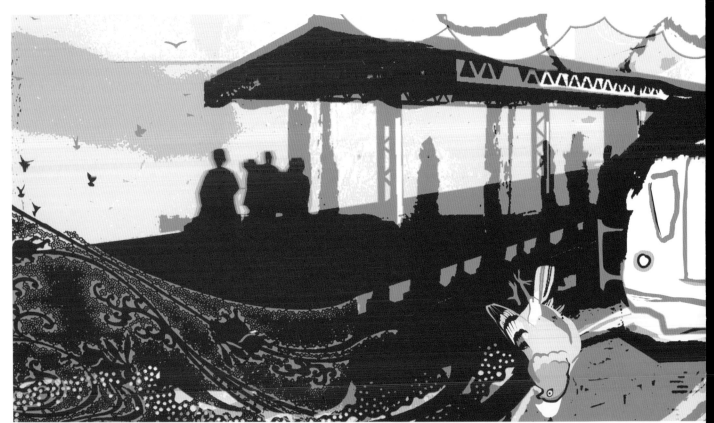

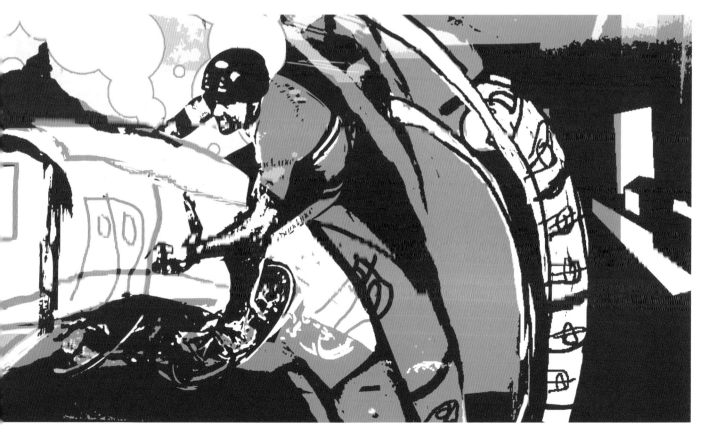

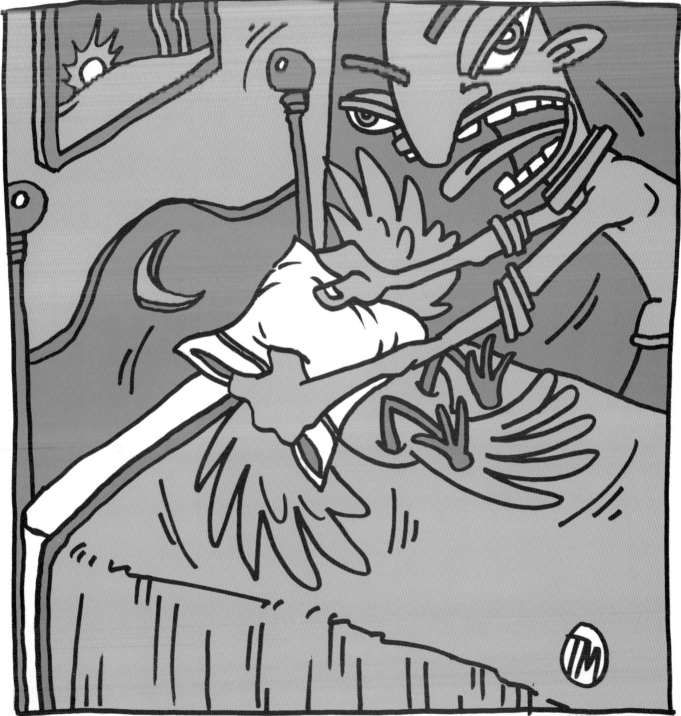

#43
THE SWEET
DREAMS

1 pillow

Crawl in bed next to your pigeon and say goodnight. Slowly pull the pillow from under your head and place it over the bird's mouth. Continue smothering until you're sure it has absolutely, positively suffocated to death. (Because if you fail to kill it, you'll be up half the night explaining yourself.)

#44
THE DARK AGES

1 bucket of burning hot tar

1 down-filled pillow

Catch a pigeon and cover it with burning hot tar. Next, cut open a down-filled pillow and let the feathers fly. Then simply sit back and laugh as you contemplate the beautifully ironic situation at hand.

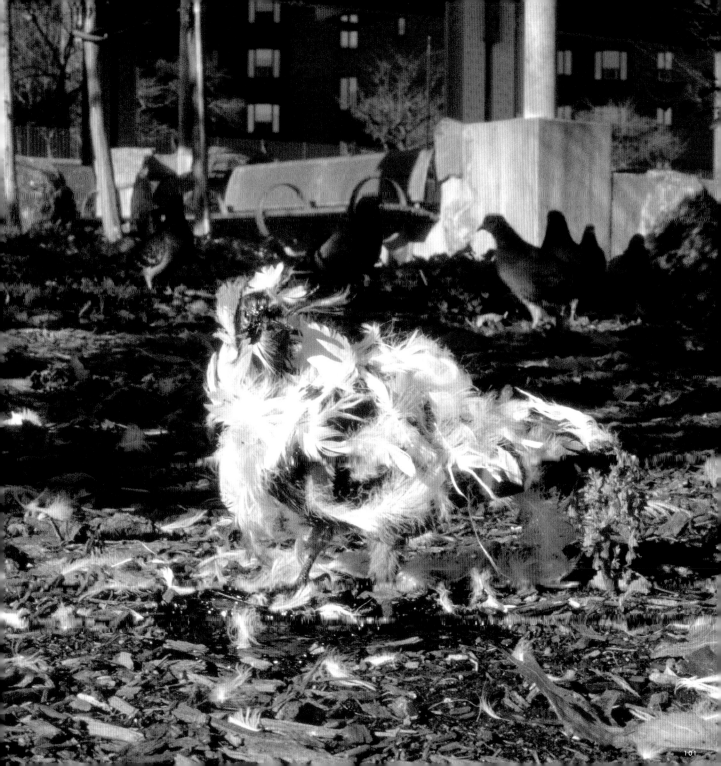

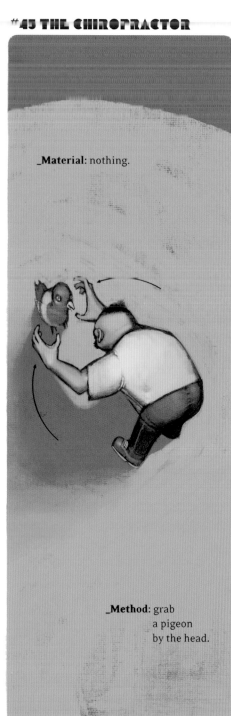

_**Material**: nothing.

_**Method**: grab
a pigeon
by the head.

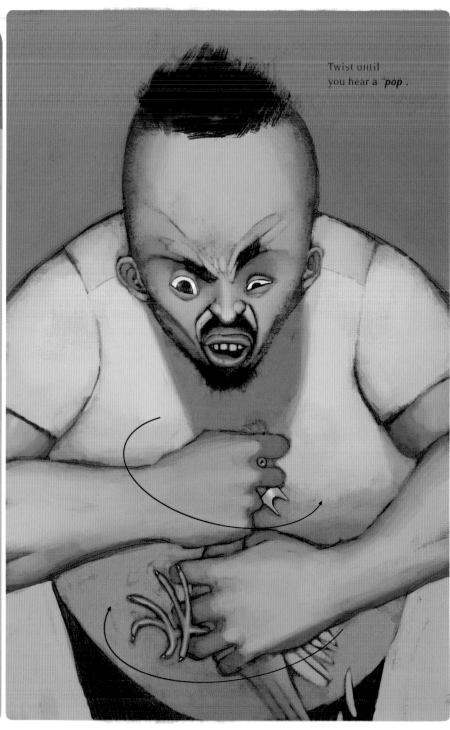

Twist until
you hear a *"pop*.

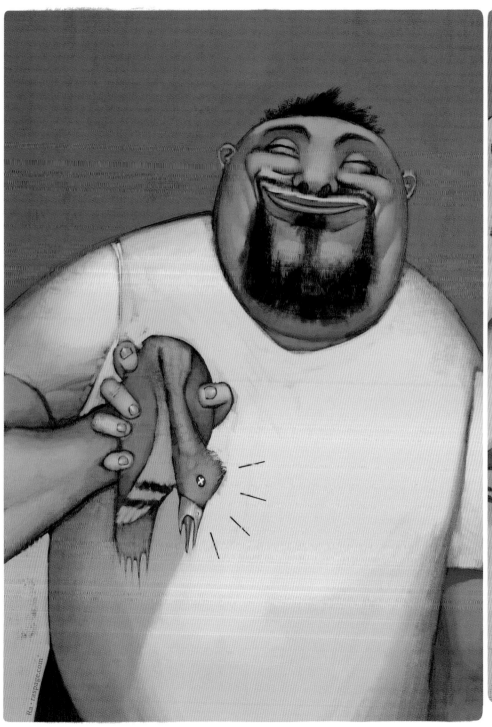

_Grab another bird and **repeat**...

#46
THE HEADLESS HORSEMAN

1 very heavy door
some bread

Simply break off a few pieces of bread just inside a very heavy, slightly-open door. As a pigeon goes for a nibble, slam the door like you mean it. Repeat until a) you shake the door off its hinges, or b) you've put Mr. Pigeon on the endangered species list.

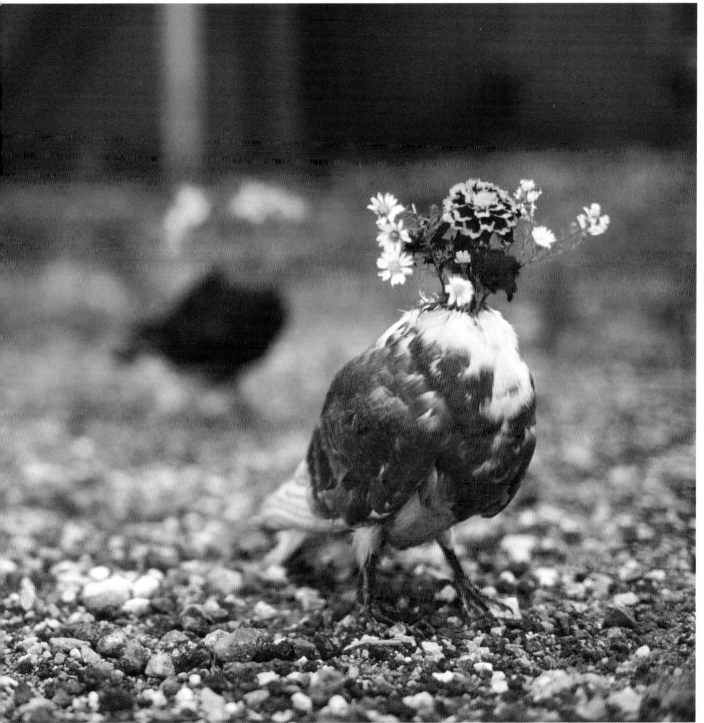

Horsepower — you gotta love it. Especially when it comes to getting the job done with maximum efficiency. Sure, you have to deal with gas, maintenance and other junk like that, but there's nothing like the sound of a perfectly-tuned Hemi. Plain and simple, whoever invented the internal combustion engine should be bronzed and displayed at the Smithsonian.

Sure, you'll find critics who argue against the implementation of heavy machinery. They reason it takes the sport out of it. That it gives us an unfair advantage. UNFAIR? Hello? Pigeons have wings! The can fly! How fair is that? I say all's fair in love and war.

The following methods put you exactly where you like to be — in the driver's seat. You'll be at the helm of boats, cars, steamrollers and forklifts to get the job done and get it done right. Gentlemen, start your engines!

AT HOME BEHIND THE WHEEL

#47
THE CLIFFHANGER

1 station wagon
1 brick
some bread

Trick your grandmother out of her station wagon. Next, coax several pigeons into the back using some bread, then drive straight toward a nearby cliff. Place a brick on the gas pedal and bail out just before the car reaches the edge. Finally, dust yourself off and hitchhike home.

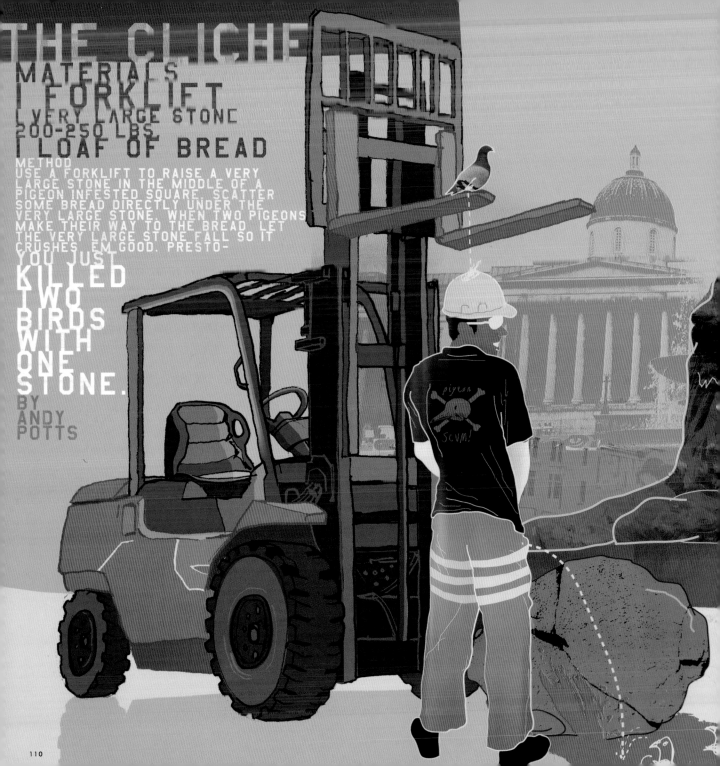

THE CLICHE

MATERIALS
1 FORKLIFT
1 VERY LARGE STONE
200-250 LBS.
1 LOAF OF BREAD

METHOD
USE A FORKLIFT TO RAISE A VERY
LARGE STONE IN THE MIDDLE OF A
PIGEON INFESTED SQUARE. SCATTER
SOME BREAD DIRECTLY UNDER THE
VERY LARGE STONE. WHEN TWO PIGEONS
MAKE THEIR WAY TO THE BREAD, LET
THE VERY LARGE STONE FALL SO IT
CRUSHES 'EM GOOD. PRESTO-
YOU JUST

KILLED
TWO
BIRDS
WITH
ONE
STONE.

BY
ANDY
POTTS

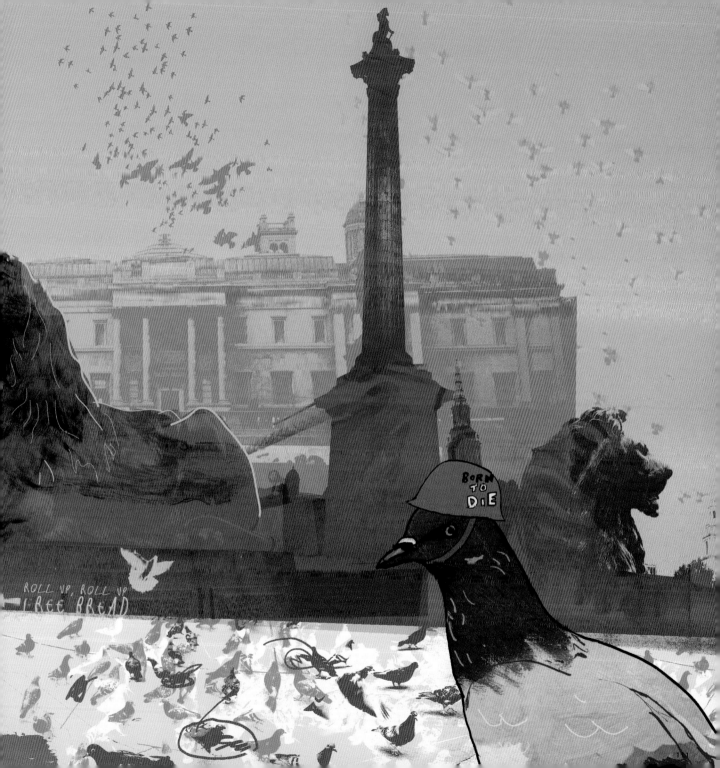

#49
THE ROAD TRIP

- I running automobile
- 1 scorching-hot desert
- I large rubberband
- I friend

Catch a pigeon and take it for a long drive. Run out of gas in the middle of a scorching-hot desert. Tell the rubberband-bound bird you'll be back shortly and have a friend pick you up 1/2 mile down the road. After a week or so, return with the gas, step over the pigeon carcass and be on your way.

#50
THE JOUST

- 2 cars
- 1 friend

From 1/4 mile apart, you and a friend drive toward each other at a high rate of speed. Just before meeting in the middle, toss a pigeon out the window and watch it explode like a Fourth of July firework.

#51
THE FLAPJACK

1 steamroller
some rubberbands

Due to the high cost of steamrollers, don't buy one, rent it. Slowly (like you have a choice) drive down the street launching rubberband-bound pigeons directly into the steamroller's path. Assuming you rented under a false name, park it and hitchhike home.

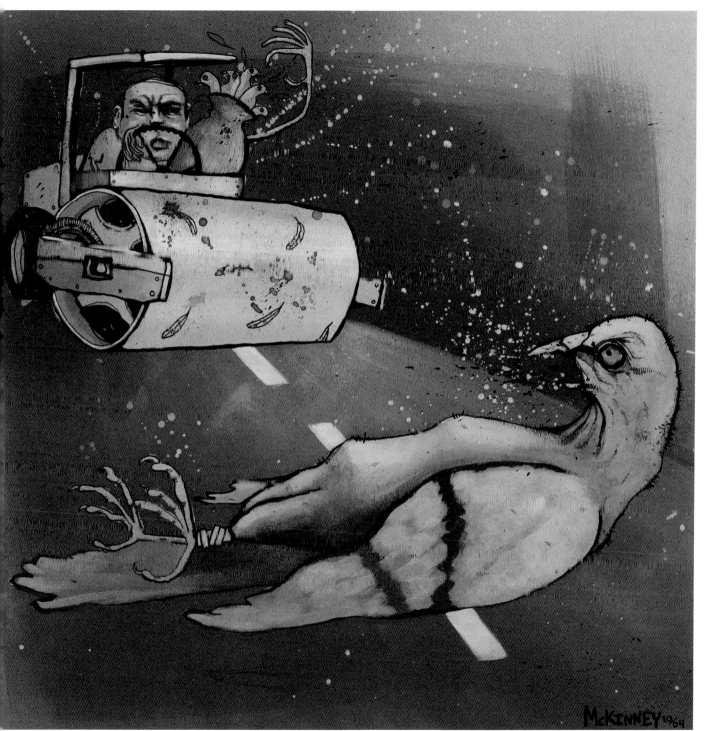

McKinney 10/64

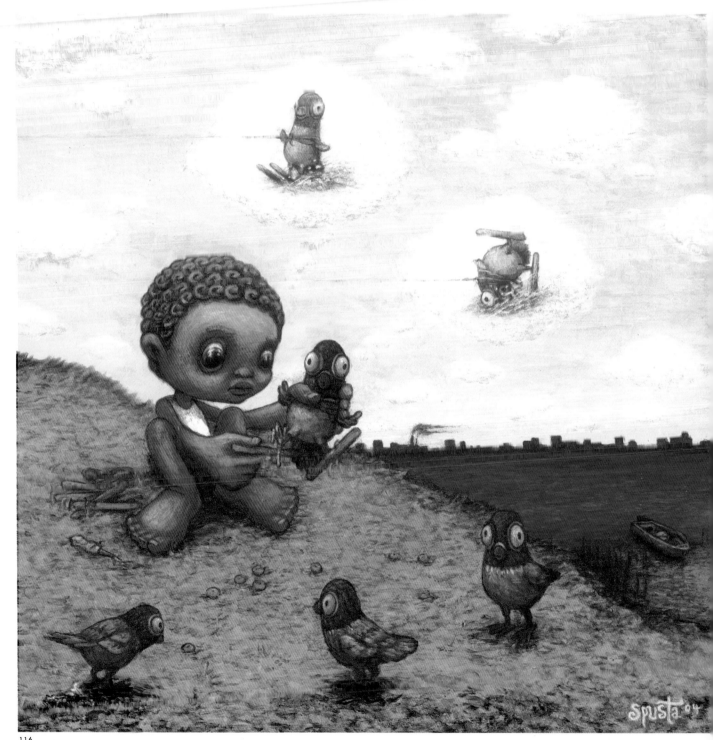

#52
THE DAY AT THE LAKE

2 popsicle sticks
1 water ski boat
1 tube of superglue
1 large rubberband
some rope

Superglue a popsicle stick to each foot of a rubberband bound pigeon. Tie one end of some rope to the bird and the other end to a ski boat. As you get up to full speed, toss the pigeon into the water. Communication will be difficult, so assume it's having a ball and drive until you run out of gas.

#53
THE SUCKER

1 industrial car vacuum
1 bag of 10 penny nails
some bread

Create a trail of bread to lure several birds into the backseat of your car. Once you've got a load, drive to your local car wash and use the vacuum to suck up every last coin, gum wrapper, French-fry and pigeon. Finish the job by sucking up a bag of 10 penny nails.

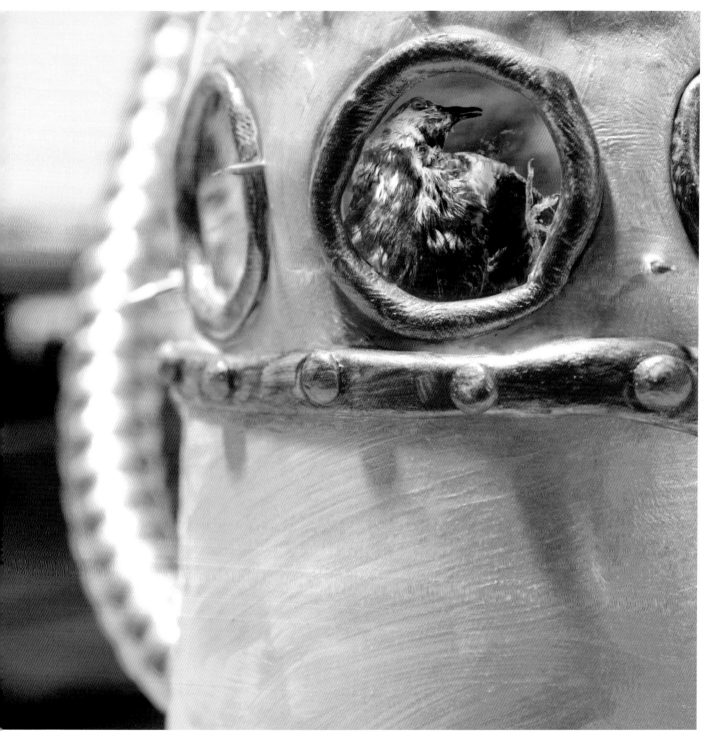

I once made the mistake of asking a new mom when she planned on going back to work, to which she snapped, "Being a mom is work!" I stand corrected.

Moms, in the spirit of Rosie the Riveter, you too can play a major role in our latest war effort. And the best part is, you won't even have to leave home! In between loads of laundry and soap operas, you can whack birds left and right with nary a break in your daily routine. And even better, now you can join in on dinner conversations with the rest of your family regarding everyone's latest kills.

The following methods were made just for you. Most require little more than everyday household items. In fact, you've probably got a whole arsenal of deadly weapons right at your fingertips. Go ahead, invite other moms over and make a party of it. It'll be fun!

STAY-
AT-
HOME
MOMS

#54
THE PERMANENT PRESS

2 household irons
1 gas mask

Wearing a gas mask, use two scorching-hot irons to sandwich a pigeon. Continue pressing until all movement has stopped. Assuming you kept the receipt, return the irons and claim they're defective.

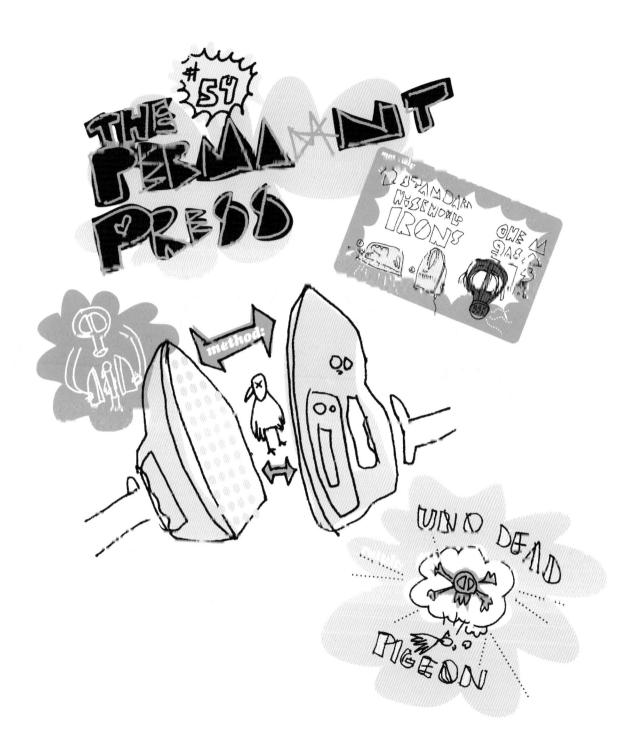

#55
THE POPSICLE

Sweet sweet pigeons, I would never want to hurt you. Flying so
high in the sky, I am jealous of your point of view. Like a free
spirit, you go where you want and capitalize on all opportunities
as you see fit. Spending time with friends, you work as a team,
but sometimes I find you reflecting life while perching on a
window sill. Floating next to the clouds, you shit on my car and
sometimes my shoulder. You seem pretty from afar, but up close...

I can tell you are dirty. If I did want to kill you, I would catch you, maybe with some bread crumbs and a butterfly net. I would tie your wings with shoelaces and put you in my freezer. It doesn't matter how much you scream, I will kill you. You will die. And once you are dead, I will take your frozen body out of the freezer and smash you with a hammer. I will tear you apart with an ice pick. Goddamn you pigeons. You filthy filthy beasts of flight.

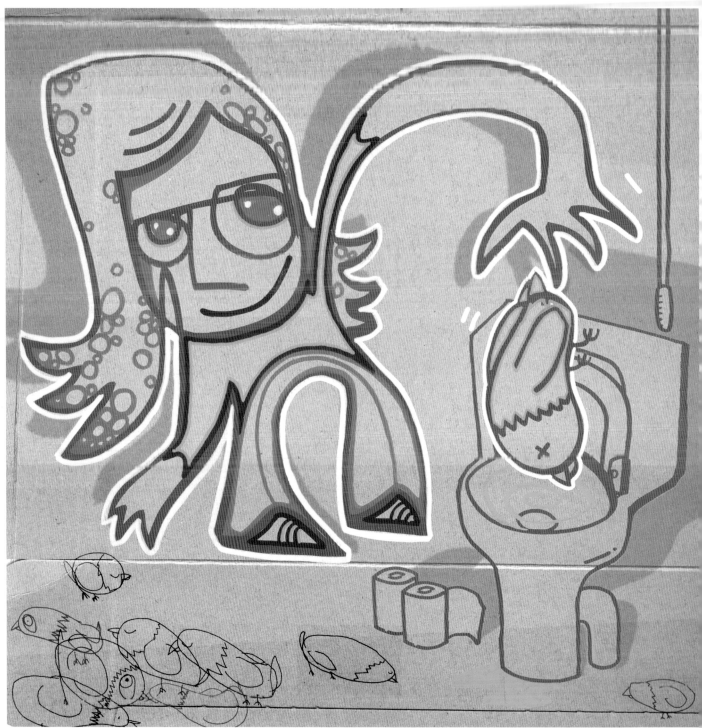

#56
THE DEAD GOLDFISH

1 toilet

Place a pigeon in your toilet. Close the lid and sit down. Flush. Repeat three or four more times before the fun is over and you've helped reduce the pigeon population by a crucial 1.

1 microwave
1 extension cord (50-75 ft.)
some bread

Run an extension cord from a nearby outlet into a pigeon-infested square. Plug in the microwave open the door and spread several bits of bread inside. Set the timer and stand out of the way. Just as a few birds enter the unit slam the door shut. The cycle will begin and a few seconds later you'll hear a "pop."

#57
THE TIMESAVER

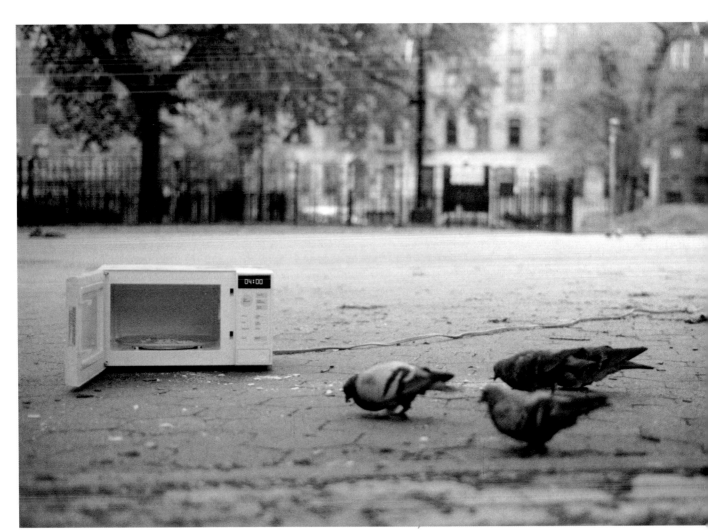

1 large blender
1 50-ft. extension cord
some bread

Break up an entire loaf of bread in your backyard. Once a few pigeons have gathered, sneak up and place a blender over as many as possible. After pressing either the "liquefy" or "chop" buttons, use an extension cord to plug into the nearest outlet.

#58
THE PURÉE

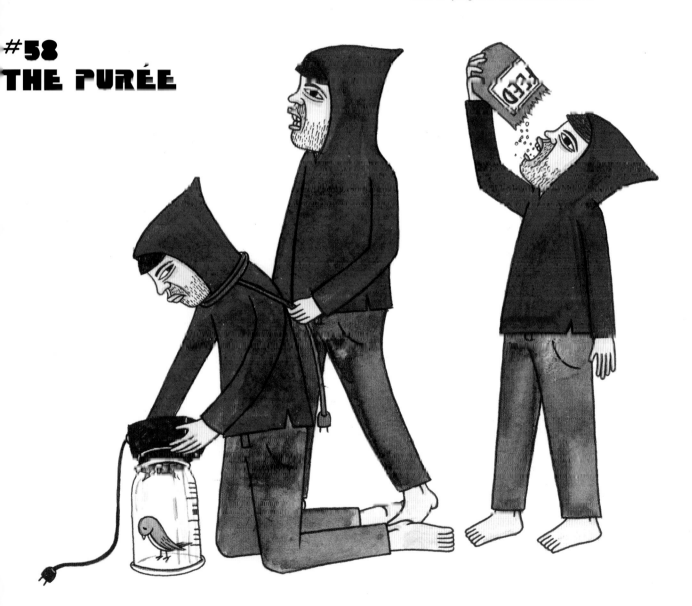

Catch a pigeon and use superglue to seal its mouth shut. When you're sure the glue has fully dried, release the bird and continue the procedure until you run out of glue. Not only will the birds eventually shrivel up and die from starvation, but you won't have to hear 'em complain about how hungry they are.

1 tube of superglue

#59
THE DIET PLAN

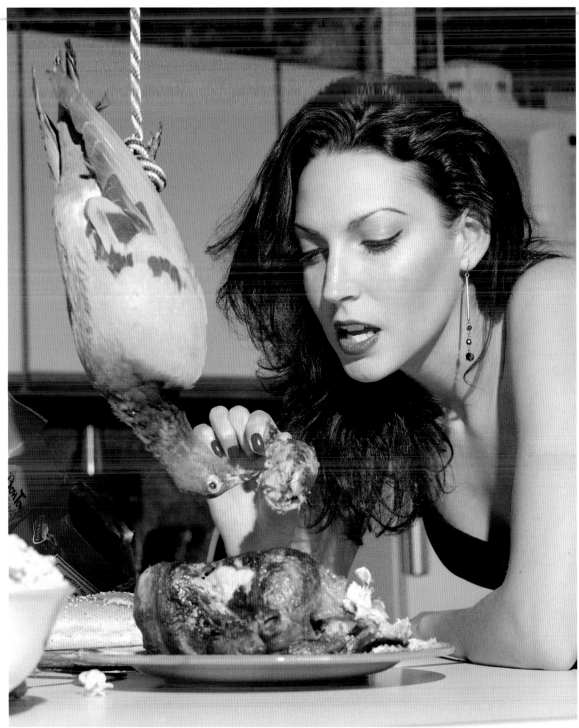

#60
THE STARVIN' MARVIN

10-12 ft. of rope
1 large rubberband
various food products

Using some rope, hang a rubberband-bound pigeon from the ceiling above your kitchen table. Over the next several days taunt the bird with each delectable bite of what you're eating. Eventually, when the pigeon stops participating and appears to be sleeping, the game is over — you win.

#61
THE CROWN
OF THORNS

1 large rosebush
1 large net
1 broom handle

Find a rosebush with a large number of razor-sharp thorns. Release several pigeons at the base of the bush and immediately cover it with a large net. A long broom handle will help coax them to flap, thrash and attempt escape. Continue prodding until all movement has come to a stop.

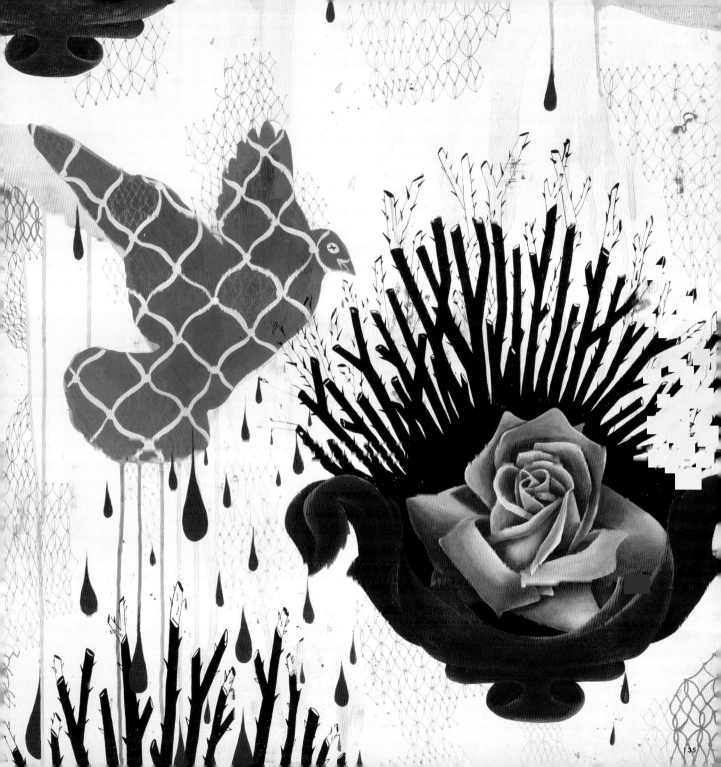

This chapter is for those of you who consider blaze orange your favorite color. You don't live in the city and human contact isn't high on your priority list. Pigeon killing comes perfectly natural to you, and you probably don't even need my help. In fact, the only reason I devoted an entire chapter to you is because I figured if I left you out there's a chance you'd get all Rambo on my ass and hunt *me* down. And that wouldn't be very productive now, would it? After all, I'm just the messenger.

So don't be offended if the following methods come across a bit elementary. I know you can do better, and probably will. Not that you need a perfect reason to fire up your Bronco with the "Back Off!" mud flaps, but this is it. And remember, pigeon-hunting season is always open.

HUNTERS & OUTDOORSMEN

#62
THE GRIZZLY
ADAMS

1 rusty bear trap
some bread

Set a rusty bear trap in the middle of a pigeon-infested square. Carefully scatter an entire loaf of bread on and around the trap. As the birds enjoy dinner the ensuing frenzy will unleash your steel savior. It will be loud. It will be messy. It will be the most glorious sight you've ever seen.

139

#63
THE GREAT
OUTDOORS

1 campfire
1 sharpened stick

As the members of your group begin roasting hotdogs around the campfire, use a sharpened stick to skewer the pigeon you brought along in your backpack. Slowly rotate the bird over the fire, then "accidentally" drop your meal directly onto the burning hot embers.

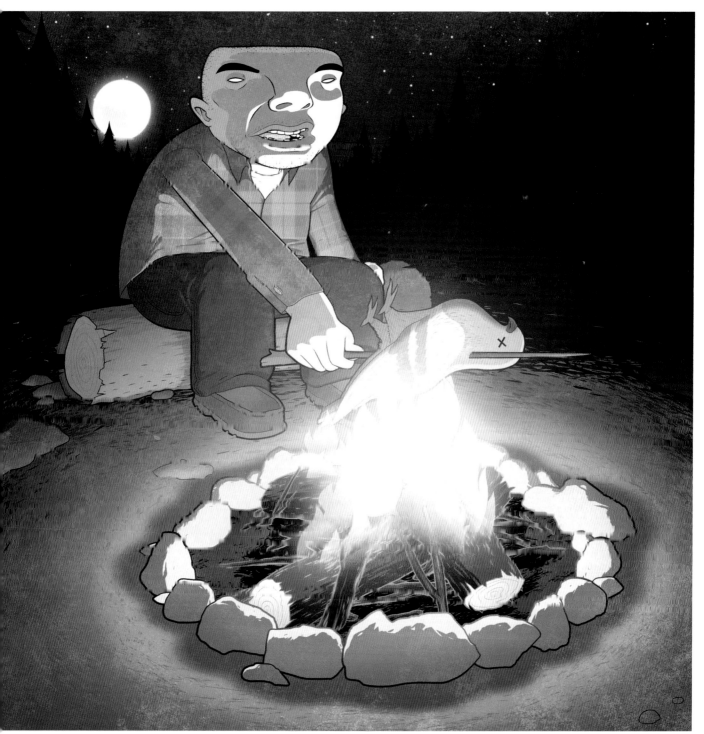

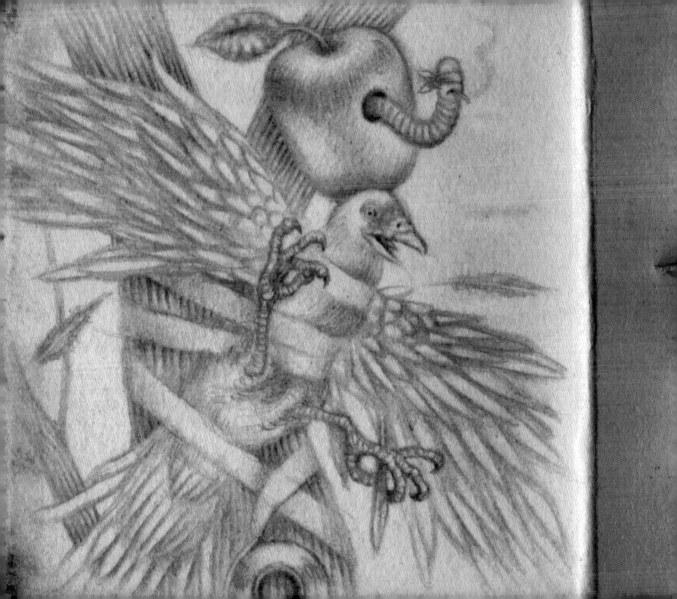

$$y = 1-t \Rightarrow y = 1-x^2$$

#64
THE WILLIAM TELL

1 crossbow
1 apple
1 arrow
some duct tape

Duct tape a pigeon to the trunk of a tree and place a juicy red apple on top of its head. Using a crossbow, carefully aim for the apple. At the exact moment you pull the trigger, cough violently. Nice shootin', Tex.

#65
THE TROPHY

1 shotgun
several shotgun shells

Load shotgun. Aim shotgun at nearest wretched pigeon. Pull trigger. Repeat.

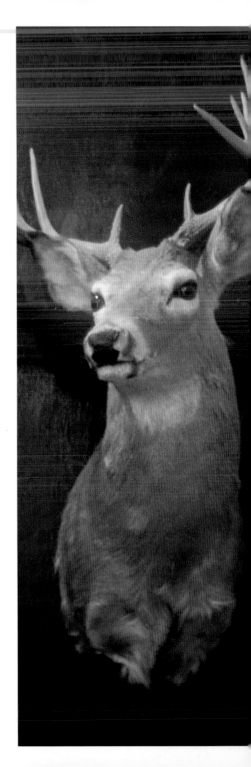

1 cat
1 burlap bag
some rope

Starve your neighbor's cat until it's good 'n hungry. Place it, along with a few pigeons, in a burlap bag. After tying the bag closed with some rope, give it a good heave-ho toward the middle of a deep lake.

#66
THE BUNDLE OF JOY

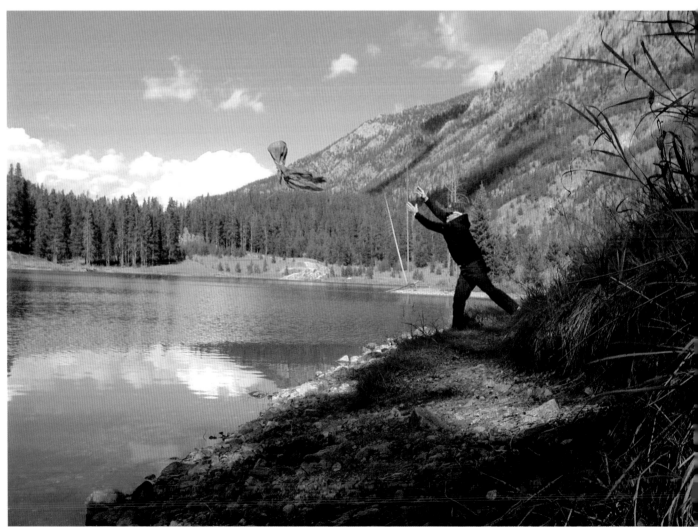

1 bullwhip
some balloons

Convince a neighborhood kid to hold a balloon in his/her mouth. Using a bullwhip, practice until you're able to miss the kid completely. Keep practicing until you're able to miss the kid *and* hit the balloon. Next, head to a park and show off your new talent.

#67
THE LION TAMER

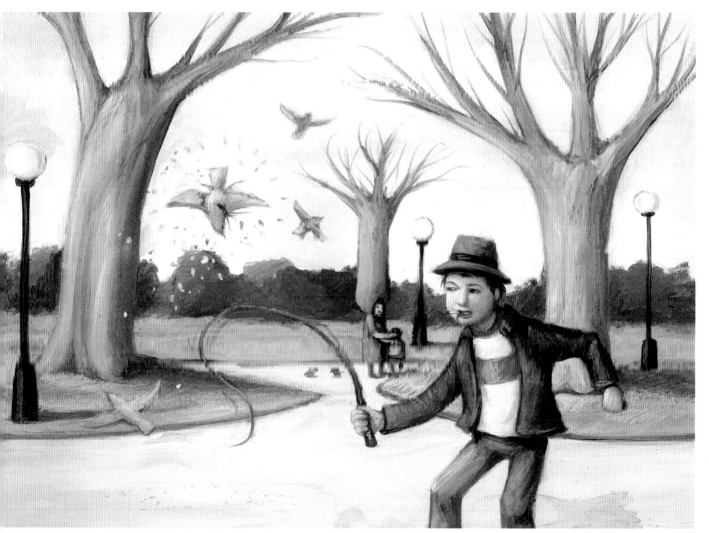

#68
THE TIMBER!

1 high-powered chainsaw
some duct tape

Practice using a chainsaw until you're pretty sure you won't cut off your toes. Since the noise is sure to scare your victims away, duct tape one pigeon to each tree in a nearby forest. Next, fire up that baby and swing away.

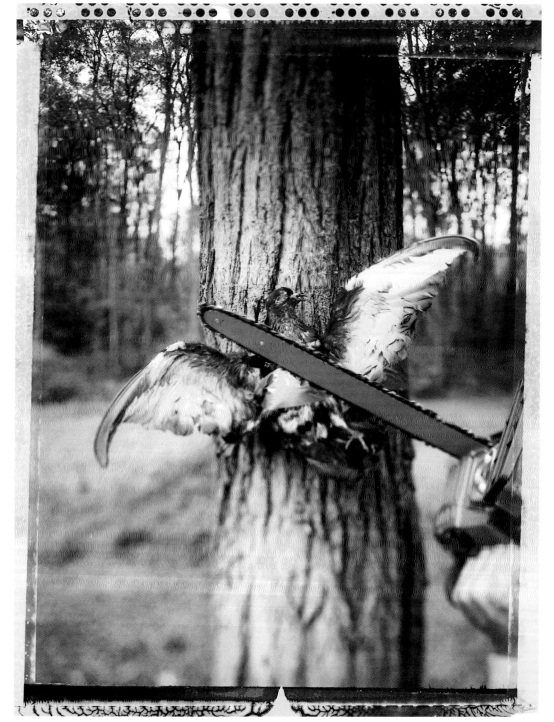

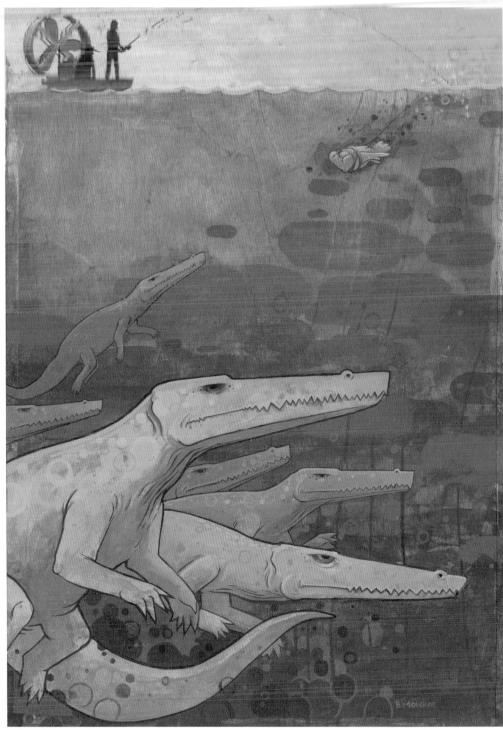

#69
THE FISH STORY

- 1 plane ticket to Florida
- 1 fishing rod
- 1 large rubberband

In the Florida Everglades, have your guide stop the boat in an area notorious for its high gator population. Grab your rod, tie the fishing line around a rubberband-bound pigeon and cast away. When the gator hits your line, immediately throw your rod in the water. Sorry, no gator-skin boots for you.

#70
THE ABORIGINAL
ASSASSINATION

20-30 blowgun darts
1 blowgun
some poison

Dip several blowgun darts in poison. Load one dart in blowgun. Aim. Blow. Repeat.

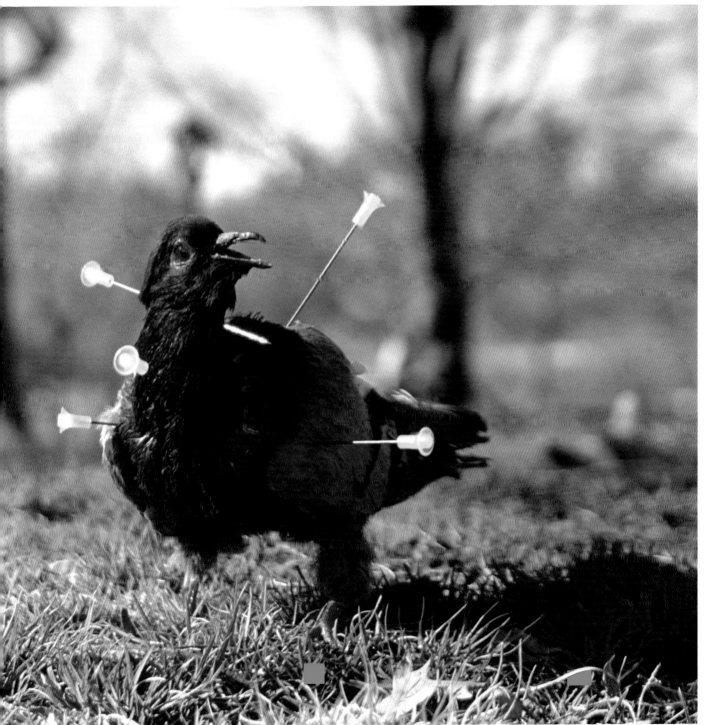

Times are tough these days, huh? Maybe you're just not trying hard enough. Or better yet, you just don't have the right motivation. Folks, it seems a little obvious to me, but why not get paid for something you love to do? Look, I like collecting unemployment checks as much as the next guy, but sitting around playing video games isn't exactly aiding our cause.

The following methods are for those of you a little down on your luck in the employment category. Oh sure, you're probably a little overqualified, Mr. Fortune 500 CEO, but how many other job offers have you gotten this week? Just don't go into the job interview throwing around your credentials. We're talking minimum wage here. Minimum wage with maximum pigeon-killing potential. Who knows, maybe you'll find your true calling.

THOSE CUR-RENTLY BETWEEN

#71
THE "DUCK" HUNT

1 tranquilizer needle
several tranquilizer doses
several 12-gauge shotguns

Get a job at an amusement park in the shooting range. Before work one day, replace the metal ducks with tranquilized pigeons, and the wimpy BB guns with 12-gauge shotguns. *Now* you're ready for business. Shout, "Step right up, everyone's a winner!"

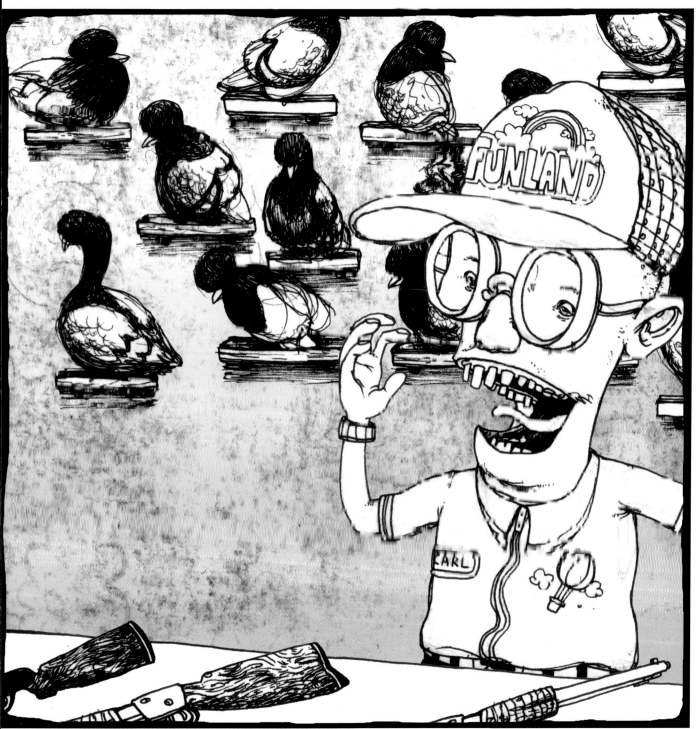

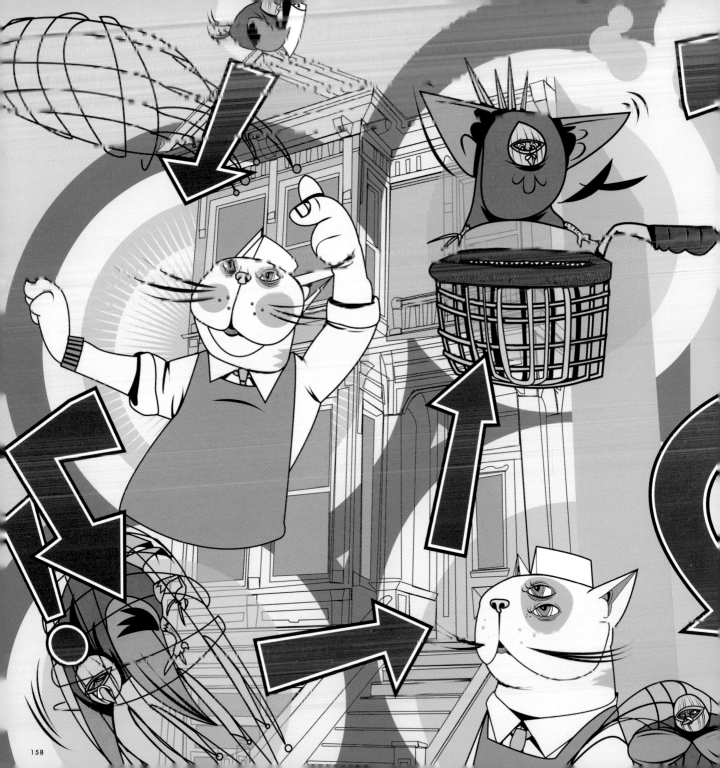

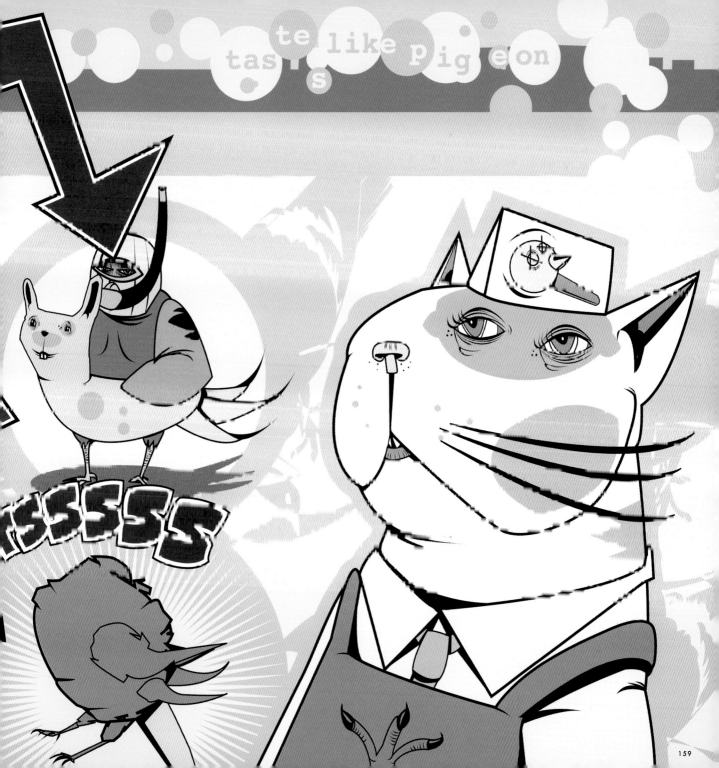

#72
THE MINIMUM WAGE

1 deep fryer
some frozen fries

Get a job working the deep fryer at a fast food restaurant. During a smoke break, grab a few pigeons and sneak 'em back inside. Place the birds in a fry basket and cover with fries (so if your manager walks by he won't suspect a thing). Slowly lower basket, birds and fries into the burning-hot oil.

#73
THE EARTHQUAKE

1 paint can (1 gal.)
1 paint-shaking machine

Get a job in the paint department of your local hardware store. Place a pigeon in an empty 1 gal. can, seal the lid and secure in the paint-shaking machine. If it's making too much noise, simply fill the can half full of paint. After five minutes or so, open up the top and check to make sure the color is indeed pigeon-blood red.

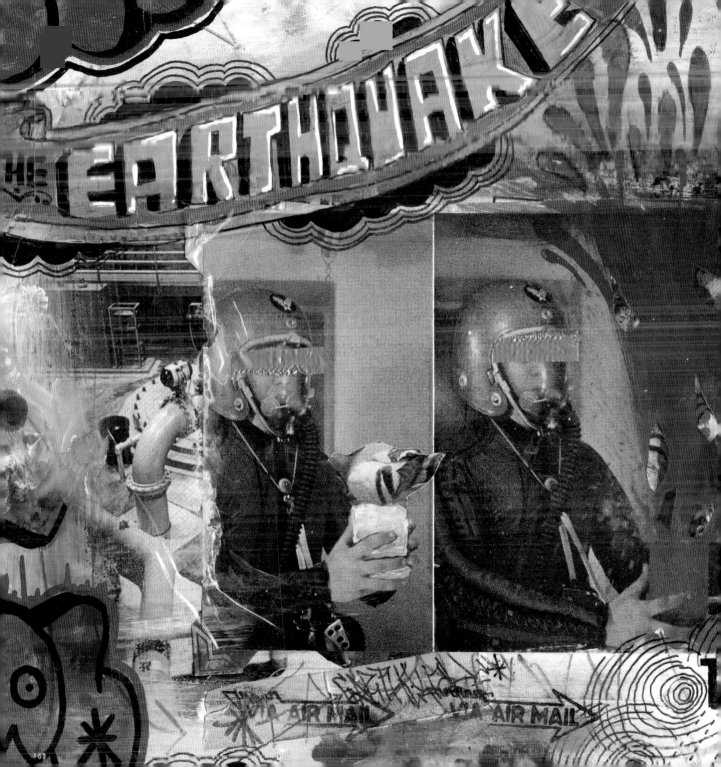

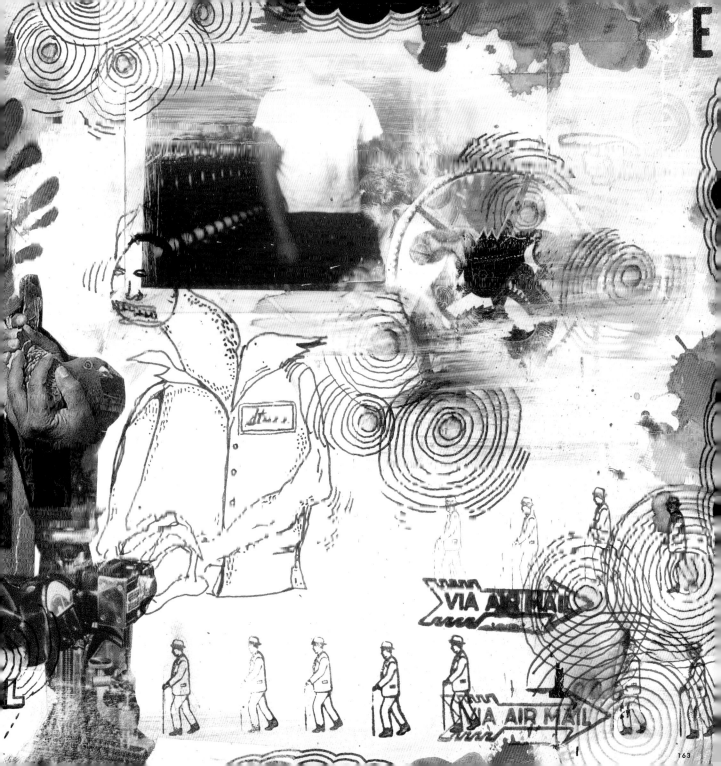

E

VIA AIR MAIL

VIA AIR MAIL

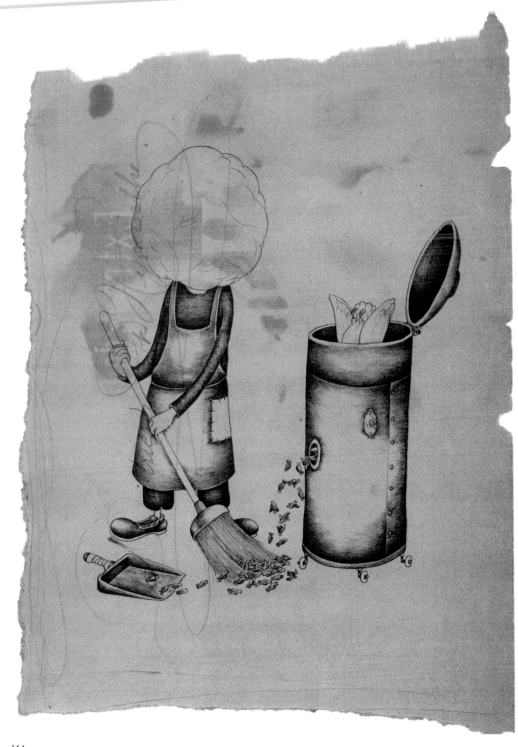

#74
THE DOCUMENT

1 paper shredder
1 broomstick

Get a menial job in a downtown office building. When everyone's at lunch, force a pigeon into the company paper shredder. It might need a little coaxing, so use a broomstick to jam down until every last feather has been shredded. When your boss returns from lunch, demand a raise.

#75
THE SUBSTITUTE

1 tranquilizer gun
several tranquilizers
several scalpels

Get a job as a substitute biology teacher. Enter the classroom and give each student a tranquilized pigeon and a scalpel. Instruct them to dissect it as if it were a frog. Once the blood starts to flow, sit down and start writing your Teacher of the Year speech.

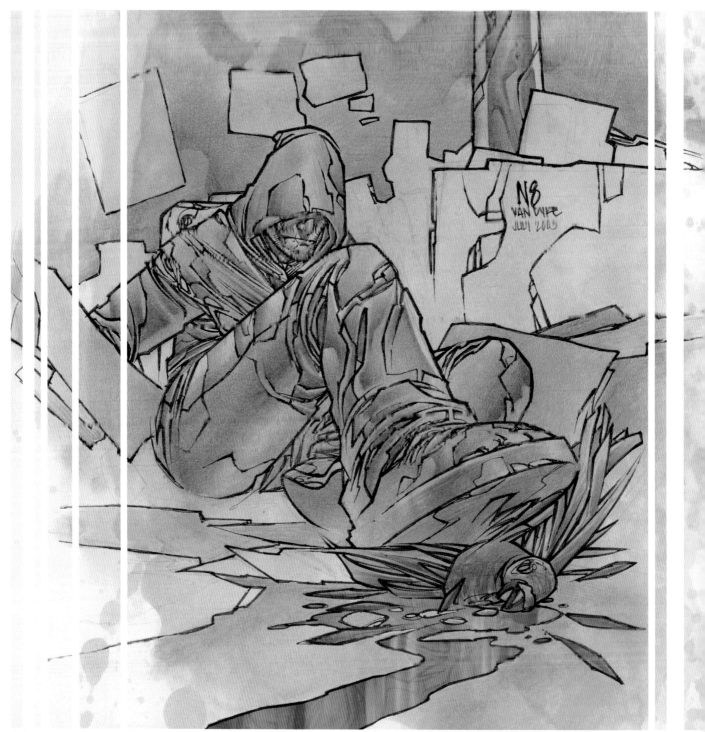

#76
THE WINO

lots of whisky
some discarded pizza

At the end of a three day drinking binge, wake up in
an alley and secure a piece of discarded pizza to the
bottom of your shoe. Next, cover yourself with trash
and wait for a pigeon to start snacking on the pizza.
With a quick and forceful motion, slam your foot
down on the bird. Go in search of aspirin.

#77
THE #56

Get a waiter's job at the sleaziest Thai restaurant in town. Convince the owner how much money he'd save by serving pigeon in place of chicken. Chances are he's already doing it for select dishes, so push those like nobody's business.

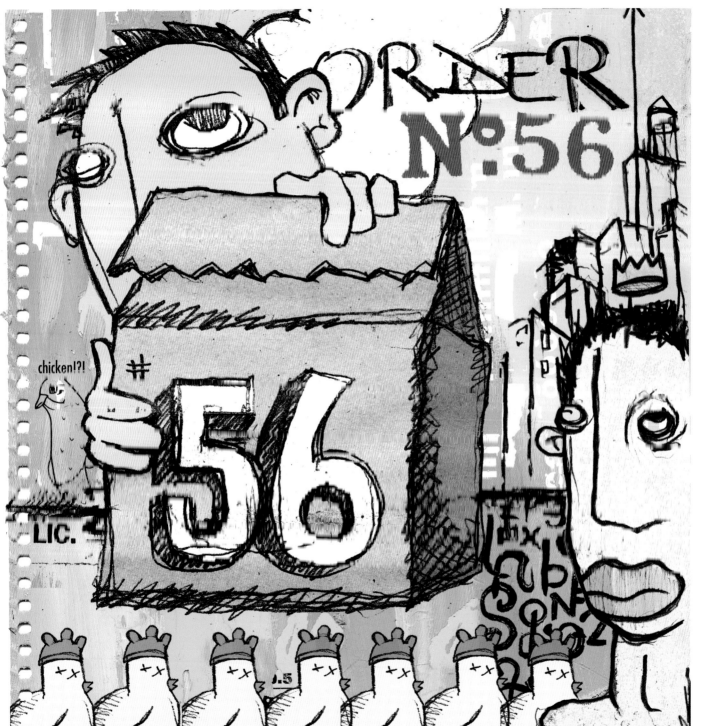

So a lot of concerned parents have wondered if it's safe to bring their children into the pigeon-killing fray. As a matter of fact, it is! Any argument about kids who torture animals growing up to be mass murderers is simply unfounded. First of all, in most cases we're not talking about torture, but flat out killing. And secondly, I started killing pigeons at an early age and I didn't become a mass murderer. So there.

Plain and simple, kids make perfect soldiers in this campaign. They're more imaginative. More creative. And they have gobs of natural energy. If only parents would stop making them go to school and clean their rooms, our job would be finished and we could move on to more important things. Like cats.

By all means parents, bring your kids to the front lines. They'll make us all proud.

SOME-THING FOR THE KIDS

#78
THE AUNT MABEL

1 bear-huggy aunt

In case your aunt isn't the bear-huggy type, borrow one. Introduce yourself and your flock of pigeon friends to her. In no time flat, she'll be huggin' like there's no tomorrow. Eventually, squirm your way out and watch as she suffocates every last bird between her bosoms.

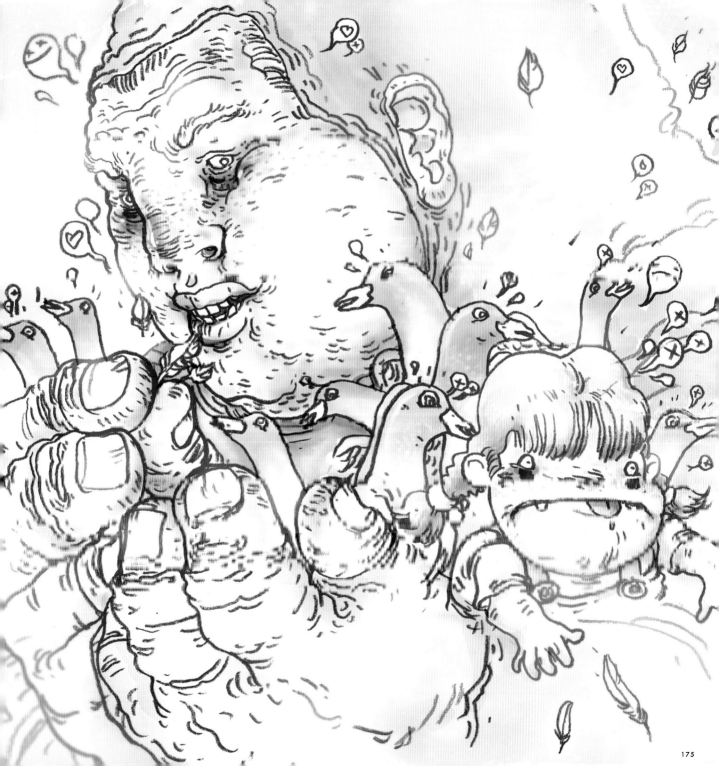

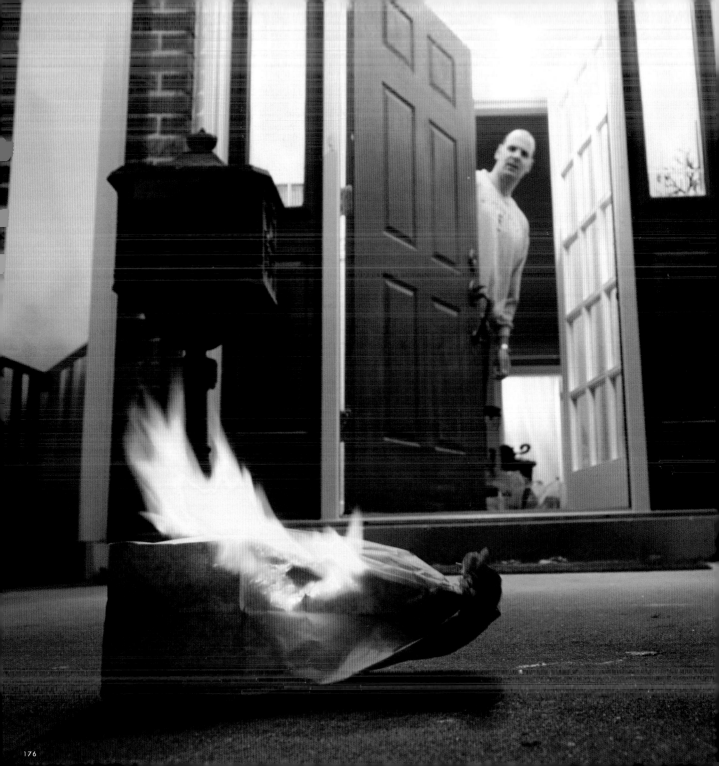

#79
THE PRANKSTER

1 paper bag
1 book of matches

After placing a pigeon in a large paper bag, twist the top so it can't escape. Set the bag down on your neighbor's doorstep. Light the the bag on fire, ring the doorbell and run. When the neighbor sees the flaming bag, they'll stomp it out with their foot. When they realize it wasn't filled with dog poop, they'll thank their lucky stars.

#80
LA FIESTA

8 children (ages 4-9)
1 broomstick
1 blindfold
some string
some rubberbands
some candy

At your kid's 7th birthday party, attach one end of some string to an overhead beam and the other end around the neck of a rubberband-bound pigeon. Blindfold one child at a time, spin them in a circle and point their errant swings in the direction of the "piñata." Pass out some candy and send the children home.

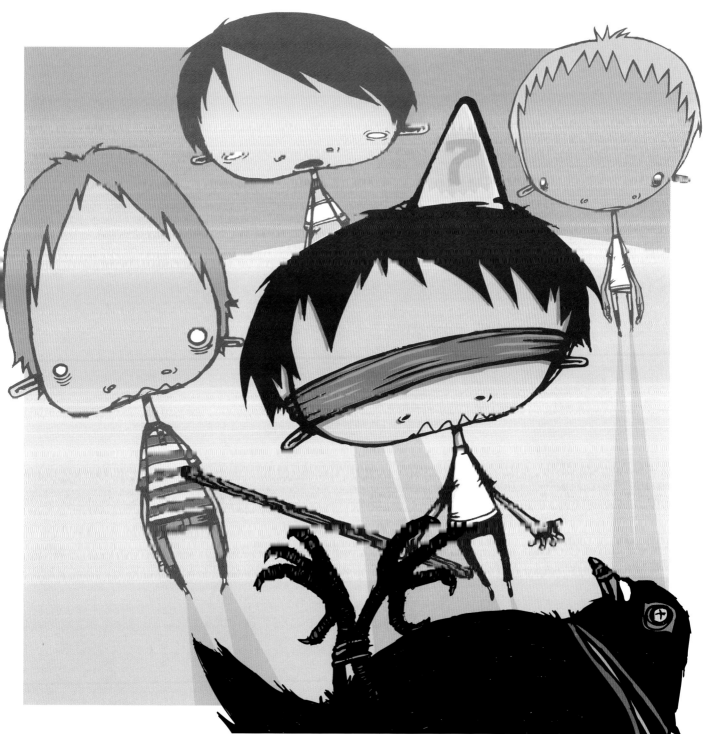

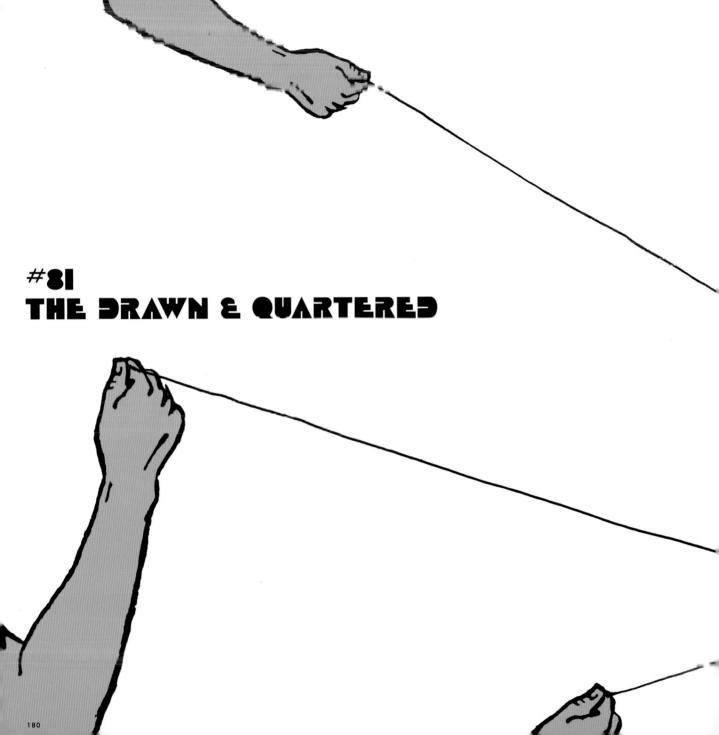

#81
THE DRAWN & QUARTERED

1 ball of string
6 neighborhood kids

Tie six 5-foot long pieces of string around the neck, tail, wings and feet of a pigeon. Next, hand one string each to six neighborhood kids. When you yell, "Go!," have them all run in opposite directions.

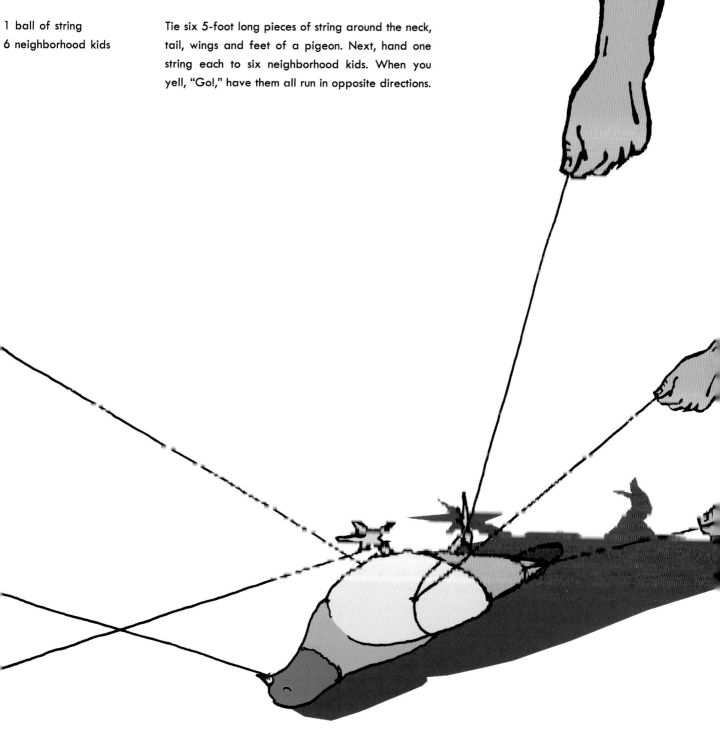

#82
THE BIND

1 large bag of industrial strength rubberbands

Wrap an entire bag of rubberbands around every inch of a pigeon — the tighter the better. What you do with it is open for interpretation. Play basketball. Throw it off a building. Kick it around. Toss it into traffic. The choice, my friend, is all yours.

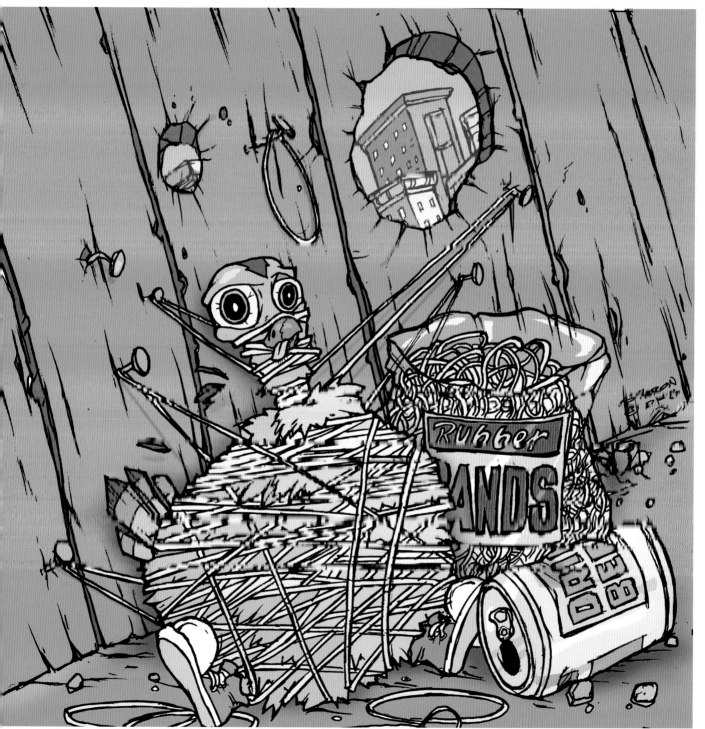

1 package effervescent tablets
1 can of soda
1 funnel
some duct tape

Duct tape a pigeon on its back to a flat surface. Using a funnel, force several ground-up effervescent tablets down the pigeon's throat, followed by an entire can of soda. Give the bird a good shake, set it on the ground and run away as fast as humanly possible.

#83
THE 'SPLODER

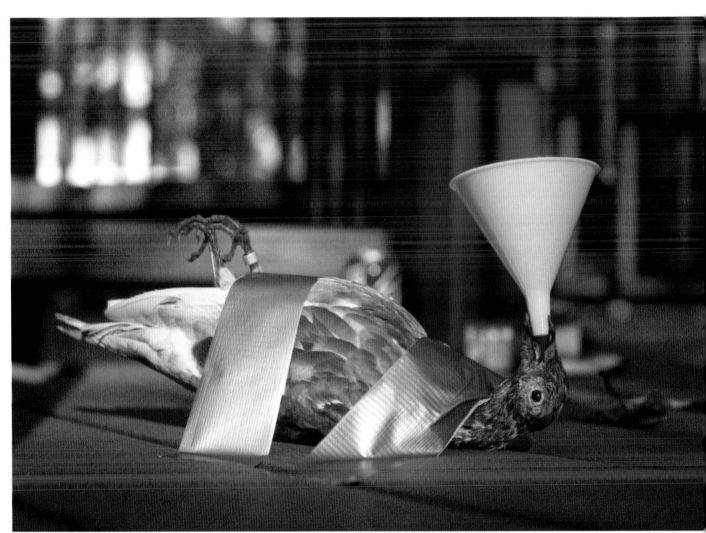

1 package of firecrackers
1 large rubberband
some matches

Wrap an entire package of firecrackers around the head of a rubberband-bound pigeon. Light the fuse and seconds later you'll have made the world a better place.

#84
THE ROCKET'S RED GLARE

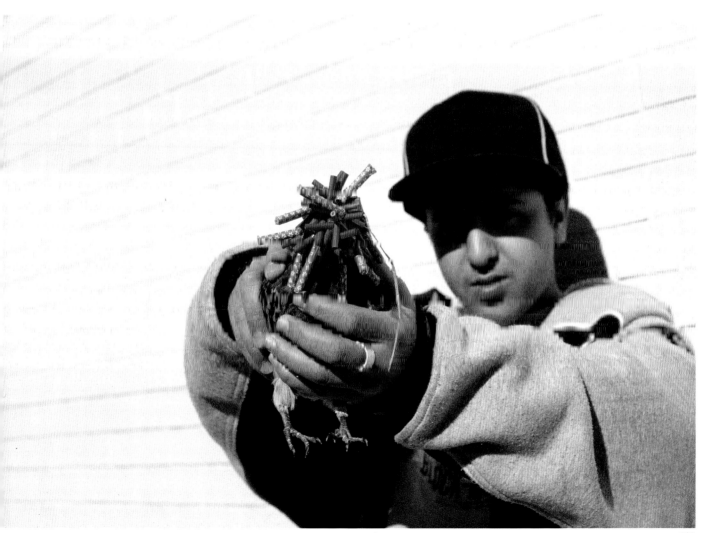

#85
THE BATTER UP

1 t-ball team
a few rubberbands

Convince the coach of a local t-ball team to make things a little more interesting for the kids by using rubberband-bound pigeons instead of a ball. Grab a couple of foot-longs and take a seat in the stands.

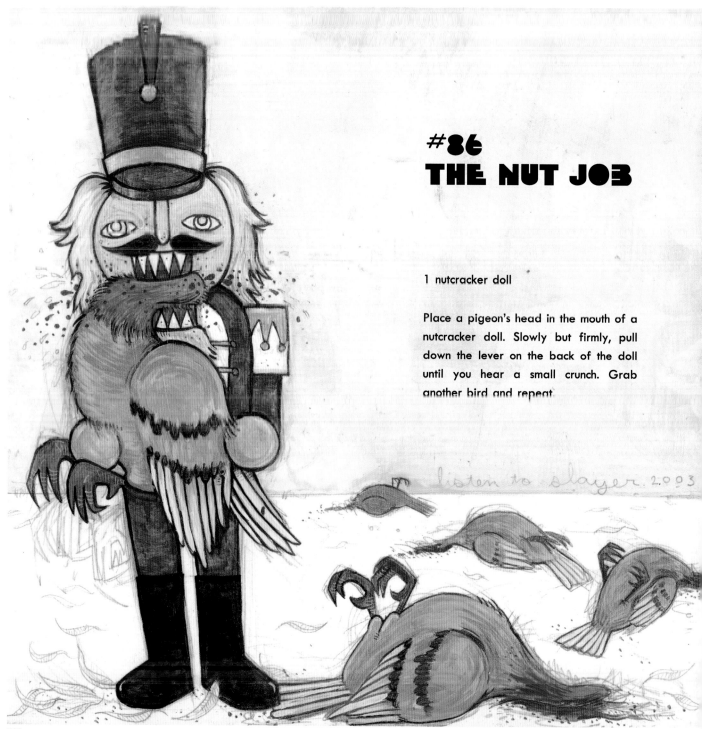

#86
THE NUT JOB

1 nutcracker doll

Place a pigeon's head in the mouth of a nutcracker doll. Slowly but firmly, pull down the lever on the back of the doll until you hear a small crunch. Grab another bird and repeat.

listen to slayer. 2003

a small box
1 portable CD player
several Top 40 CDs

Place a pigeon in a small box with an opening large enough for its head. Pick out some of the worst Top 40 music you can find and use a portable CD player to make it listen at full volume.

#87
THE TOP 40

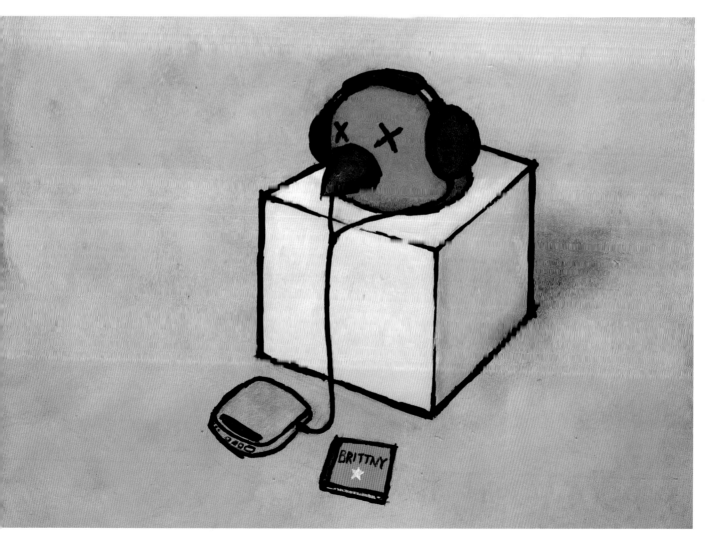

It's obvious why no professional sports teams have been named *The Pigeons*. Talk about a guaranteed loser! What I can't understand is why ESPN doesn't create a show about pigeon killing? I mean, if there's an audience for the Lumberjack World Championships, surely there should be one for pigeon killing. With contests like "3 Minute Kill" and "Weapon of Choice" it'd be a sure hit!

Until then, I've come up with some methods for those of you who love sports. And not the armchair kind. I'm talking about getting out there and doing it yourself. After all, why not add a little challenge to things?

Let's get the blood pumping and adrenaline flowing. Let's create champions of the sport. Let's run up the score, drive it down the lane and knock it out of the park. And most importantly, let's win one for the Gipper!

SPORT LOVERS / CHALLENGE SEEKERS

//88
THE CHUCKER

1 polo mallet
1 bicycle

As you ride a bicycle to the town square, practice swinging a polo mallet in a sweeping motion just above the ground. Once you reach the square do the same thing, but time your swings so the head of the mallet meets the head of a pigeon in a moment of sheer beauty. Afterwards, head to a park and start working on the squirrels.

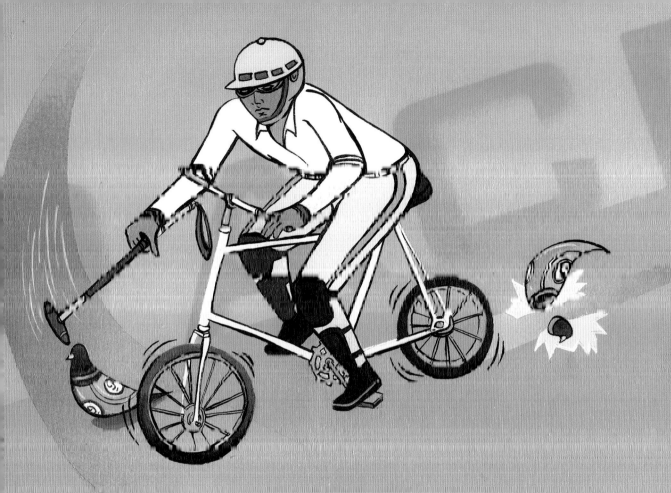

1 Kung Fu manual
some bread

After learning Kung Fu, scatter some bread in a nearby park. Once several birds have congregated unleash your mighty fury. For a little extra fun, mumble fake Chinese while one of your friends hiding behind a bench says, "Now it your time to die. Take that you disgusting bird."

#89
THE BRUCE LEE

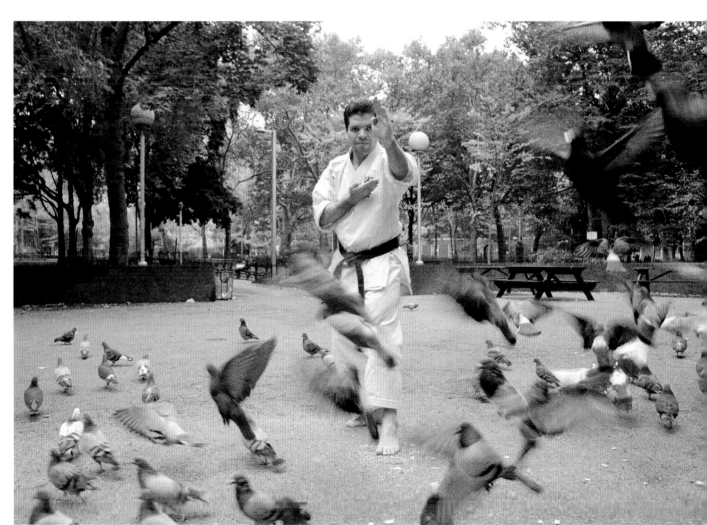

1 golf club
several sticky rat traps
some bread

Scatter several sticky rat traps in the middle of a pigeon-infested square. Break up bits of bread on and around the traps. Before long, several pigeons will be firmly stuck to the traps. Next, step up to the tee and swing away. By all means, bring a friend and keep score.

#90
THE HOLE-IN-ONE

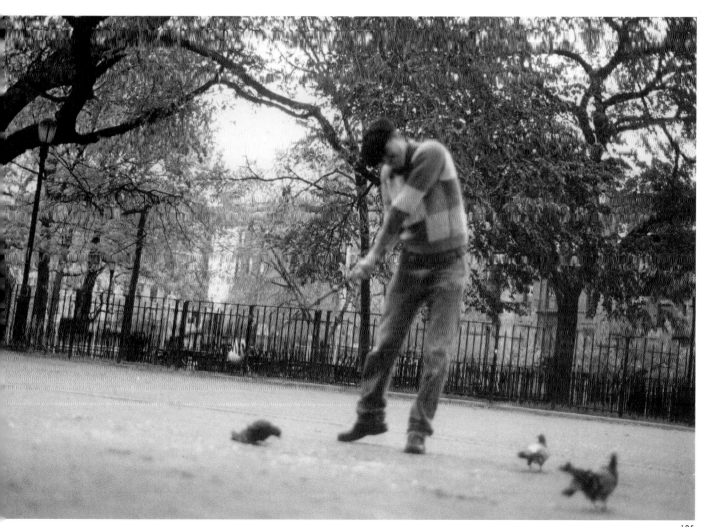

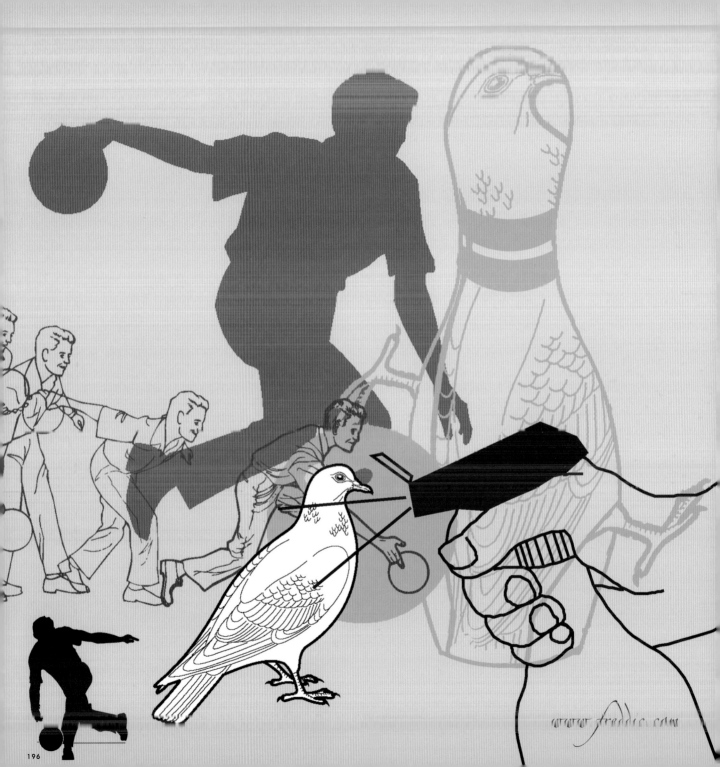

www.freddie.com

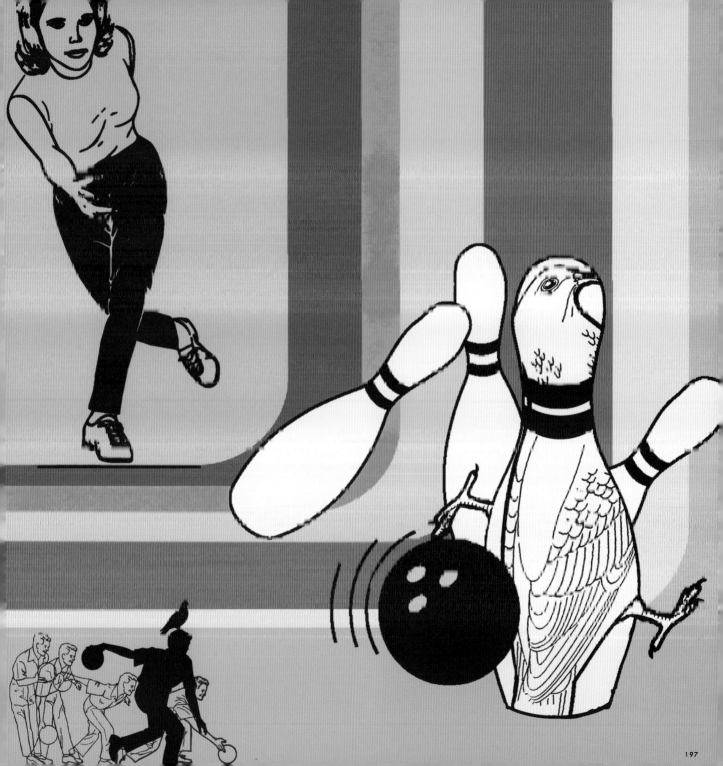

#91
TH LEAGUE NIGHT
◀

1 bowling alley
1 bowling ball
1 spray bottle
some starch

Head to your local bowling alley and replace the front pin with a starched pigeon. Next, grab a 25-lb. ball and let 'er rip. A straight-on shot will smash the thing to smithereens. A not-so-straight-on shot will force you to pick up the spare. A gutter ball will cause people to point and laugh.

#9
THE EXTRA POINT
▶

1 pro football kicker

Hire a professional football kicker to take a stroll with you down a pigeon-infested street. Agree on a key word like "doldrum" or "cinnamon" that you'll say when you want the kicker to let one fly. Once he gets the hang of it, challenge him to launch the birds through open windows.

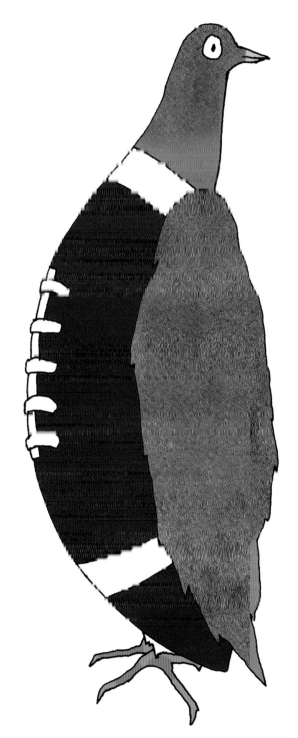

#93
THE ACE

1 tennis racket
1 tennis ball machine
some rubberbands

Load a tennis ball machine with rubberband-bound pigeons and point it toward a brick wall. As the birds come flying toward you, wrap both hands around a tennis racket and swing for the bleachers.

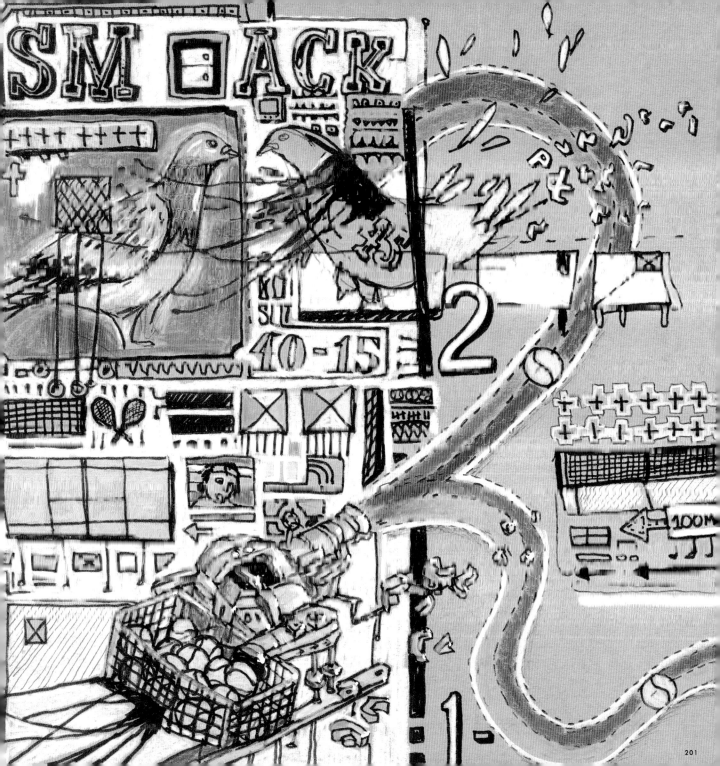

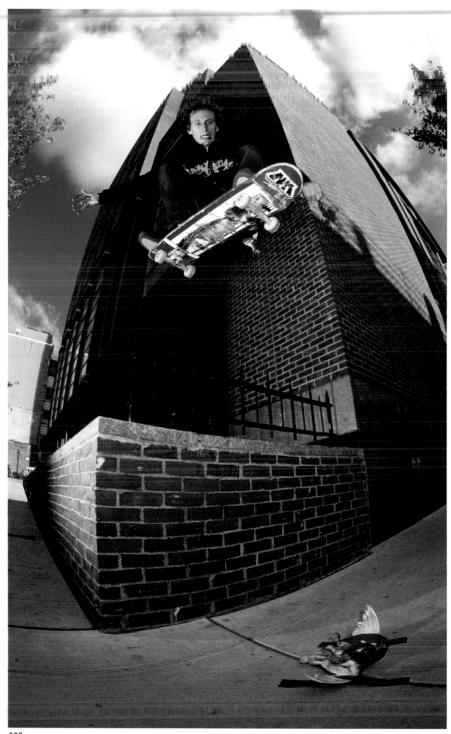

#94
THE SKATE & DESTROY

1 skateboard
I roll of duct tape

Find a suitable location to launch 7-10 feet into the air on a skateboard. At the landing area, secure a pigeon to the ground with duct tape. Unless you're Tony Hawk it might take a few tries to score a direct hit, but remember, Rome wasn't built in a day.

#95
THE JUMPER

1 hot air balloon
1 bungee cord (200 ft.)
1 detailed waiver

After convincing a brave pigeon to accept a free bungee jump, make it sign a detailed waiver. Take the balloon up 150 feet and tie a 200 ft. bungee cord around the body of the bird. When he's ready let him "fly." Bring the balloon down and see if you have any other takers.

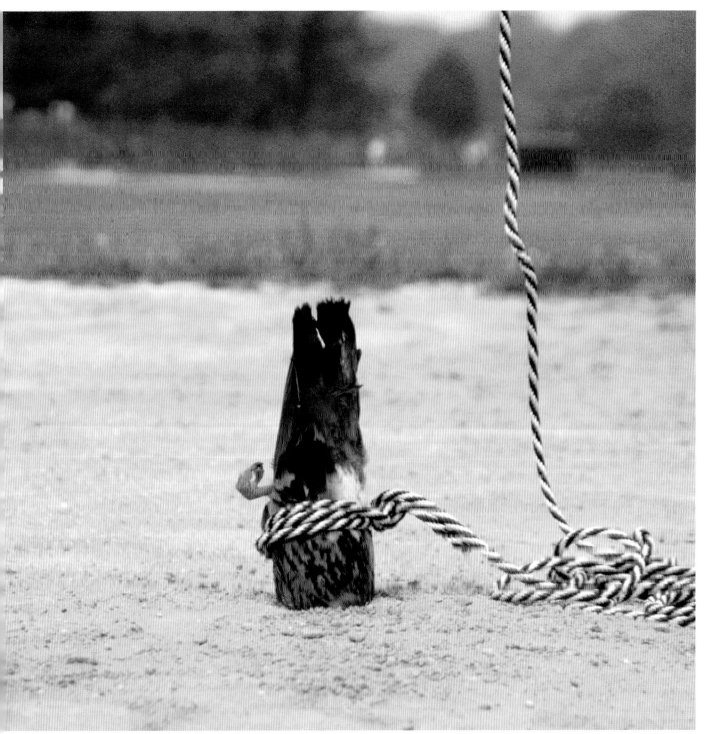

During my last visit to Rome I tried to get a meeting with the Pope. I wanted to convince him pigeons are the devil incarnate and he should issue a decree encouraging the eradication of the species. Imagine that, over one billion Catholics worldwide giving it their all! Well, he was busy and we didn't get a chance to speak.

That's where you come in. Maybe you're a politician. Or a Fortune 500 CEO. Or you simply have handsome good looks and a winning smile. Whatever it is, people are drawn to you like moths to a flame. They've always said you were the type who could lead people into battle, and this is your chance. Consider yourself the Pied Piper of Pigeonville.

The following methods are ways you can use that influence to further our cause. I'll keep working on the Pope as long as you keep growing your flock.

HIGHLY
INFLUEN-
TIAL
PERSONS

#96
THE FILTHY HABIT

1 pack of cigarettes
1 book of matches
some peer pressure

After making friends with a pigeon, offer it a cigarette. If it says it doesn't smoke, unleash the mighty peer pressure machine. Before long it'll work its way up to 2 or 3 packs a day with only one place to go: straight to the grave. Heck, it'll probably even take a few others down with it.

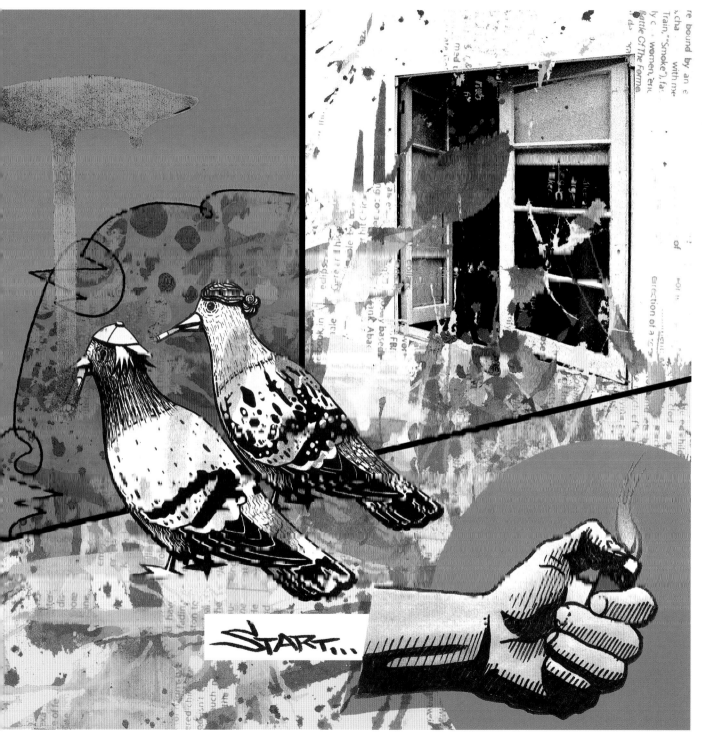

START...

209

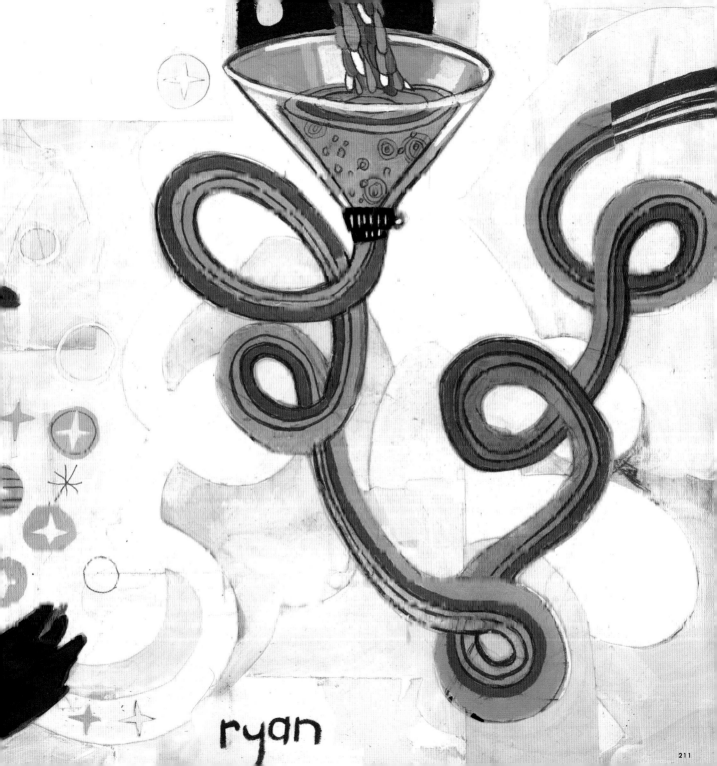

ryan

#97
THE PLEDGE

several bottles of whisky
a few kegs of beer

Pretend you're starting a fraternity for pigeons (Crappa Crappa Crappa?). Invite as many birds as possible to join during "rush" week. Make them drink until they die. Dissolve the fraternity due to a lack of membership.

#98
THE GREAT CAUSE ›

1 bullhorn
some bumper stickers
some posterboard
some magic markers
some media influence

Begin an international campaign to warn of a plague ravaging small island countries in the South Pacific. Tell the masses there's only one way to stop the human carnage — stop the carrier PIGEONS! Make up statistics and spread stories of lingering, painful death. Once you get the ball rolling, panic will take over and the human race will have you to thank.

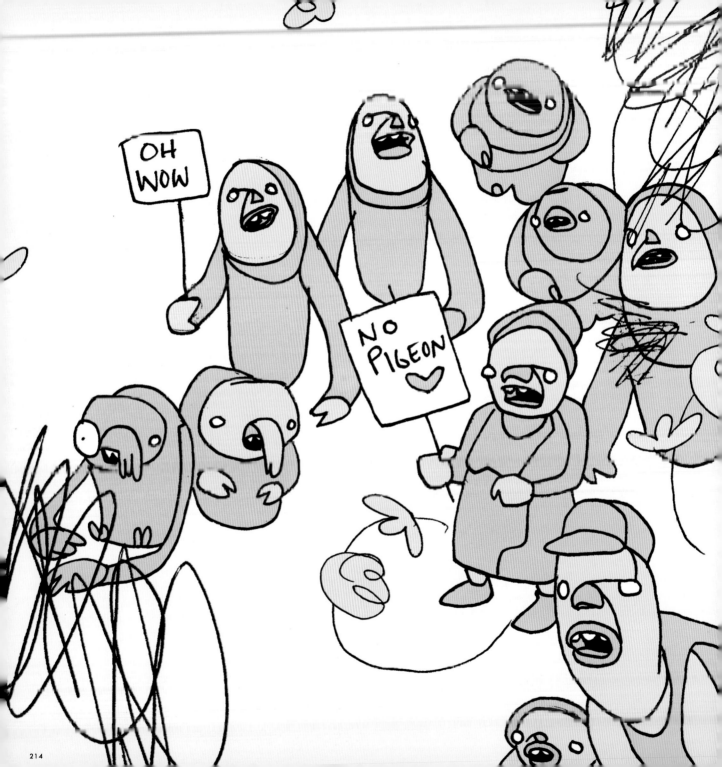

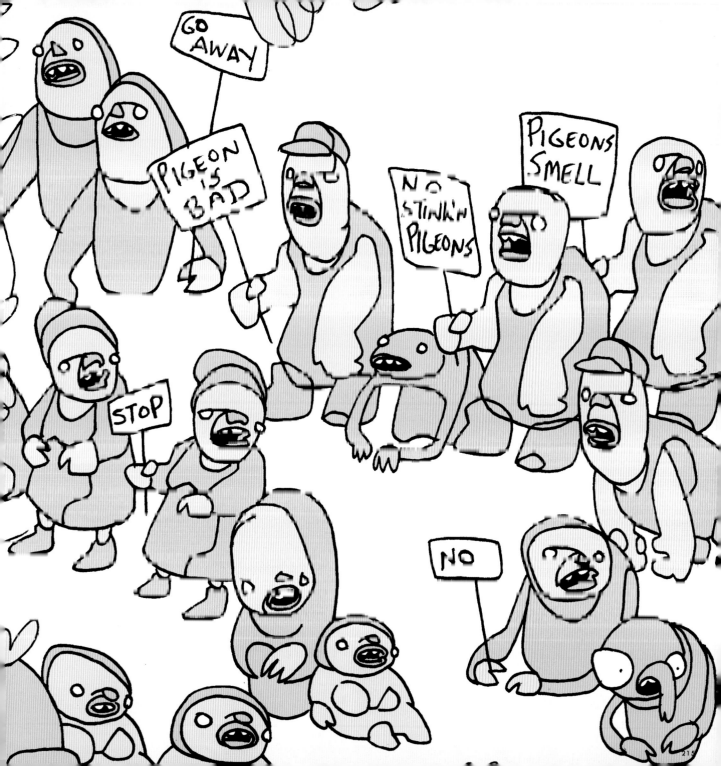

#99
THE MULE

1 lb. cocaine
1 pin
several balloons

Convince a pigeon to help you smuggle drugs across an international border. Use a small pin to poke holes in each balloon before filling it with cocaine. When the customs agent questions you, explain that your pet bird looks dead because, ironically, it hates to fly and you had to give it sleeping pills.

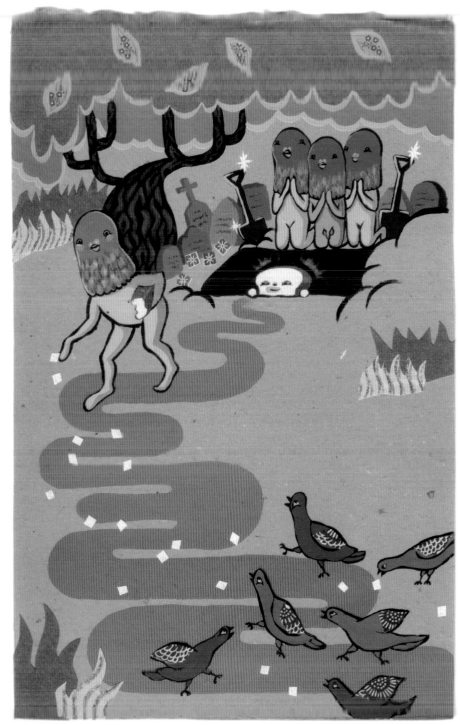

#100
THE WORM FOOD

several shovels
some bread

At a nearby park, dig a hole large enough to fit a casket. Create a trail of bread to lure several pigeons into the hole. As they enjoy their dinner have six or seven park patrons quickly fill the hole with dirt. (Have one person ready with a shovel to whack any sneaky birds attempting an escape.)

#101
THE JONESTOWN

several small paper cups
some fruit drink
some cyanide

Become the leader of a cult that only allows pigeons. Move the cult to some far away place like Guyana. Once you have them under your spell, convince your flock they must die in a "revolutionary suicide." Pass out paper cups filled with poison-laced fruit drink and encourage them to drink up.

INDEX OF CONTRIBUTORS

80-81	THE SURPRISE PARTY	Michael Sieben	Austin, TX	msieben.com
83	THE FEEDING FRENZY	kozyndan	Los Angeles, CA	kozyndan.com
87	THE BUTCHER	DALEK	Brooklyn, NY	dalokart.com
88	THE BLOW JOB	David Choe	San Jose, CA	thatfellow.com
90-91	THE SALON	Linn Kellman	Boulder, MN	alabalatter.com
93	THE O.K. CORRAL	Robert Hardgrave	Seattle, WA	framedinfusion.com
94-95	THE CARNIVAL	Kevin Cornell	Philadelphia, PA	bearskinrug.co.uk
96-97	THE COMMUTER	Eric Lundquist	Brooklyn, NY	weloverobots.com
98	THE SWEET DREAMS	Todd Marrone	Philadelphia, PA	toddmarrone.com
101	THE DARK AGES	A.V. Jones	New York, NY	killthepigeons.com
102-103	THE CHIROPRACTOR	Raoul Sinier	Paris, France	rauspage.com
104-105	THE HEADLESS HORSEMAN	A.V. Jones	New York, NY	killthepigeons.com
109	THE CLIFFHANGER	Billy Blob	Kansas City, MO	billyblob.com
110-111	THE CLOSE	Andy Potts	London, UK	andy-potts.com
112	THE ROAD TRIP	Ion Jackson	Los Angeles, CA	lagraphica.com
112	THE JOUST	LH avisualagency	Brooklyn, NY	glhava.com
115	THE FLAPJACK	Aaron McKinney	Orlando, FL	aaronmckinney.com
116	THE DAY AT THE LAKE	Marq Spusta	San Francisco, CA	marqspusta.com
118-119	THE SUCKER	Eran Wilkenfeld	Brooklyn, NY	eranstudio.com
123	THE PERMANENT PRESS	Struggle, Inc	Chicago, IL	struggleinc.com
124-125	THE POPSICLE	Dustin Amery Hostetler	Toledo, OH	upso.org
126	THE DEAD GOLDFISH	Jon Burgerman	Nottingham, UK	jonburgerman.com
128	THE TIMESAVER	Nick Goodey	New York, NY	nickgoodey.com
129	THE CURER	Mike J Coleman	Los Angeles, CA	mkgallery.com
130-131	THE DIET PLAN	Rik Catlow	Charlotte, NC	rikcat.com
132	THE STARVIN' MARVIN	Minh Ngo	New York, NY	tclixys.com
135	THE CROWN OF THORNS	Gina Triplett/Matt Curtius	Philadelphia, PA	allpick.com/ginaandmatt
139	THE GRIZZLY ADAMS	Lance Sells	Washington, D.C.	normalnatural.net
141	THE GREAT OUTDOORS	Matt Clark	Portland, OR	manbaby.com
142-143	THE WILLIAM TELL	Jason D'Aquino	Buffalo, NY	jasondaquino.com
144-145	THE TROPHY	Baldomero Fernandez	New York, NY	baldomero.org
146	THE BUNDLE OF JOY	A.V. Jones	New York, NY	killthepigeons.com
147	THE LION TAMER	Tim McCormick	Los Angeles, CA	timmccormickart.com
149	THE TIMBER!	NIVEK	Brooklyn, NY	NIVEKfoto.com
150	THE FISH STORY	Brendan Monroe	New York, NY	brendanmonroe.com